SCALA
GUIDE TO
ART ON THE
INTERNET

www. artcyclopedia.com

ScalaVision publishes a beautiful collection of ebooks about major collections and artists. These affordably priced ebooks are available via on-line retailers such as Amazon.com and bn.com and at www.ipicturebooks. com. All titles are priced under $10 and can be viewed on ordinary Windows, Macintosh and Pocket PC computers.

TITLES

ScalaVision: Italy, A Travel Guide
ScalaVision: The Downloadable Hermitage
ScalaVision: The Downloadable Impressionists
ScalaVision: The Downloadable Louvre
ScalaVision: The Downloadable Modern Artists
ScalaVision: The Downloadable Musee d'Orsay
ScalaVision: The Downloadable Neoclassical Artists
ScalaVision: The Downloadable Renaissance
ScalaVision: The Downloadable Romantic Artists
ScalaVision: The Downloadable Uffizi

GUIDE TO ART ON THE INTERNET

DOUGLAS DAVIS

ibooks
new york
www.ibooks.net

DISTRIBUTED BY SIMON & SCHUSTER, INC.

An Original Publication of ibooks, inc.

Distributed by Simon & Schuster, Inc.
1230 Avenue of the Americas, New York, NY 10020

ibooks, inc.
24 West 25th Street
New York, NY 10010

The ibooks World Wide Web Site Address is:
http://www.ibooks.net

ISBN 0-7434-3471-4
First ibooks printing June 2002
10 9 8 7 6 5 4 3 2 1

Project Editor : Valerie Cope
Cover Design: J. Vita
Interior Design : Gilda Hannah

Printed in the U.S.A.

CONTENTS

SCALA
GUIDE TO
ART ON THE
INTERNET

INTRODUCTION

We have just emerged from a century that overvalued pure technology and undervalued the human mind. Despite the fervent pleading of Roland Searles, for example, most of our scientists still can't bring themselves to confirm that anything like consciousness exists because it refuses to reduce itself to a row of properly sequenced 0s and 1s. The unique human identity each of us shares and diversifies—our consciousness, in brief—doesn't excite us. Neither does the rapid increase in the ability of this consciousness to absorb a multiplicity of facts, ideas, and history unimaginable even as recently as the 1920s when Freud formed decisive opinions about both mind and gender. But 3G mobile phones with wireless Internet access deserve headlines in every newspaper or browser window from New York to Jakarta, as do Windows XP and Panasonic's KX-HCM10 webcam (which rings an alarm if it sees anything on the Web that might distract your libido, if not your analytical intelligence).

Besides any of these devices, our expanding conceptual power not only to invent the Web but to devise ways in which to impregnate it with meaningful content (and perhaps even spawn an alternative

post-digital universe) dwarfs 3Gs, XPs, and KXs. This book, though it raps uninspired URLs and idiotic organization, places the human consciousness first, its products second. You won't find these pages filled with rave after rave for new technological "break-throughs" or simple-minded listings that don't discriminate the lean from the fat (headed).

Which is not to say we don't love, understand, and profit from all our competing raves. Their blindness (we, too, are guilty of falling for press release divas) is fueled by a fascination with the "other"—Intel's faster and faster chips, Apple's conversion in its post-G4 models to built-in DVD magnum video storage, and IBM's promise to give you a PC that will clone and respond to your voice. In one sense, our minds certainly are no match for these tools. In another sense, you and I not only provoked Intel and Apple with our hunger for fast-moving information but, more importantly, we are deciding how to use the tools, just as we decided how to revise and redesign the pencil, the paintbrush, the typewriter, the telephone, the camera, and (yes, you knew I was coming to it) the Internet and the Web.

The evolving human factor matters more than pure technology? Yes, I am contradicting my reputation as a pure-minded futurist and technocrat by answering in the affirmative. In truth this is the punch line we haven't allowed out for more than fifty years: our

minds are changing faster than all the digital chips combined. Now I have wanted to publish this idea for decades but only now can I allow myself to be so blunt, thanks to you, thanks to the occasion offered by writing this decidedly humane guide to the special place the arts hold on the Web.

And you are the key because so many of you now live via the keyboard and connect to distant spaces and times effortlessly. When I began writing about "technology" in the 1960s and 1970s, it seemed alien, clanking, monstrous. The humanist chairpersons for whom I had to lecture, the amiable editors I had to convince, the art dealers to whom I had to hand portable video cameras (to prove they weren't aliens) are now, each of them, thoroughly digitized. And you are already wheeling across the Web to show that kid on your lap the ancient cave paintings in Altamira, äda'web's electronic wizardry, etc. We all expected science and economics to gorge on the Web. We didn't expect the ribald, freewheeling creative imaginations—the Shakespeares, Giottos, and Becketts of our time—to take it over.

But they have. That is why this guide is far more humane than any Zagat directive to dining, why it can gleefully turn your mind toward content as often as possible, even when the technology and the content are folded into each other, as in certain examples of streaming video and audio. What matters to our

consciousness is not simply how something gets into our mind but what happens when it arrives. We haven't read Shakespeare over and over for hundreds of years because he used the rhymed iambic pentameter line or linked his plots to the specific dimensions of the Globe Theater. We read him because his metaphors worm into our souls and turn our consciousness upside down. The same is true of the best URLs we have recommended here. Some of them are childlike in their technical simplicity; some of them are highly advanced, employing some or all of the software we note on the following pages that you use to see, hear, and touch what is out there. Whether primitive or advanced, our favorite URLs all take specific advantage of the Web's special strengths in the creation, display, and curating of new and old art on the Web.

Prime among these advantages—what sets the Web and the computer apart from most of the media that preceded them—is live "interaction," an abused, overworked word but battered because it's a signifier for a profound human truth: no true transmission of thought, image, or metaphor is ever one-way. Duchamp told us long ago that art is always completed in the "mind of the receiver." How extraordinary that it has taken the best minds in our advanced museums—men and women who can quote Duchamp as well as I can—many years to figure that

one out on their fine-tuned, underthought websites. Instead, they have given us one glorified slide show after another, endless gift shop deals, and tepid storefront banners . . . until recently.

It's true! I am glad to report to you that many of our museums, even corporate-heavy behemoths, are engaged in a headlong flight to find ways to touch the single user sitting at your keyboard—you. They're busting to find ways to give you choices that allow you to select your own subject or artist to investigate. They are learning, in brief, that the Web audience isn't the happy faceless crowd storming into their rotundas and galleries. This is, of course, the bottom-line truth of the Internet, the original "Information Highway" exploding out of Al Gore's mouth in 1992. The Internet was devised to speed the exchange of military and scientific texts. Later, the World Wide Web hit our eyes and minds with imagery and sound (thanks to Tim Berniers-Lee).

You and I immediately figured out we could chat with, see, and hear each other on the Web. We could turn the world at once into a classroom, art gallery, private theater, dinner party, and, on more occasions that we admit, peep show. Polls consistently tell us that the vast majority of users hit the Web from all over the world, even during the day, on surveilled, censored company and government computers which are often programmed to keep them away

from sexy websites, vulgar jokes, Tim Leary, and even innocent "chatting," broadly defined.

What could be more human than the desire to see and analyze art, to read about its history, to investigate the far reaches of the digital avant-garde? What fact better proves the point that few official Web managers and corporate managers, not to say marketers and deeply serious Web prophets or philosophers, want to admit? That you and I are making a daring, advanced technology invention of our own, as we did the telephone, which Edison first thought would simply be a vehicle for presidential speeches and symphonic concerts. The fact that we're also using the Web to create new forms of art, literature, scholarship, and science runs right beside the adventure of meeting new minds halfway across the world in random chat rooms or as an accessory to daily business. Humanity is committed to the human use of almost everything, for good and for ill. How we use any tool, new or traditional, advances the mind almost as quickly (and with far more unpredictable consequences) as wireless Palm Pilots link us to the Web.

With this book we hope to enhance goodness in artmaking and interaction across the globe. And by "goodness" we don't mean classical perfection or symmetry, though God knows they are not forbidden. We mean the rich and endless unpredictability that arises when one mind touches and responds to

the other, followed by thousands, perhaps millions, of others. When we are finally linked, thinking as one highly diversified mind, we may begin to sense something like the "final truth" or "the theory of everything" now growing out of string theory, perhaps. Thank you, in any case, for acting on behalf of your own deep-seated needs, not the rules or regulations handed down by esthetic or technocratic authorities. This is a new century.

D. D.
New York City

SOFTWARE TIPS

Various software "plug-ins" are available free to enhance viewing of certain websites. These pages indentify some of the most common tools used by art websites.

COMMON SOFTWARE ADDITIONS TO WEBPAGES

Adobe Acrobat

Adobe Acrobat is an industry-standard software for creating portable documents (files that are created with whatever software one chooses, but viewable by anyone who possesses the free Acrobat Viewer). Acrobat is often used to share complex documents, such as catalogs, books, and technical manuals, which often cannot be made into standard webpages.

More information: *http://www.adobe.com/products/acrobat/*

Java

Java is unique among browser additions in that it is a fully-qualified programming language and system platform, rather than just an outlet for audio, video, or interactive multimedia. Programmers use Java to create applets, which are small programs that can be incorporated into web pages. Applets can be made to do just about anything, and are commonly used to implement scrolling or animated text, images with integrated magnification functions, games, audio and visual effects, and a host of other niceties.

The current versions of almost all major web browsers support Java. Users with outdated browsers, or text-based browsers such as Lynx, will not be able to use the interactive functions provided for by Java applets. Using Java applets in webpages is considered to be a standard practice; alternative provisions for users who cannot use Java applets are not always provided.

More information: *http://java.sun.com*

JavaScript

Although the two are often thought to be one and the same, Java and JavaScript are actually two separate—but related—programming languages with completely different methods of implementation. JavaScript is incorporated into the HTML source code for webpages, and does not generally exist as a separate applet or program. The use of JavaScript allows users to interact with many elements of the webpage they are viewing that are not otherwise accessible. For example, a script can be programmed to allow the user to change the background color of a page, or to alert the user if an item of required information has not been entered into a form.

Browser support for JavaScript is virtually ubiquitous, and, as is the case for Java applets, alternatives for browsers without JavaScript support may not always be provided.

More information:
http://home.netscape.com/eng/mozilla/3.0/handbook/javascript/

Macromedia Flash

Macromedia's Flash is one member of a relatively new breed of web browser additions. Flash gives webpage designers the ability to easily incorporate animation, sound, and graphics into a webpage. Objects created with Flash are optimized for low-bandwidth connections, so users without high-speed lines can still take advantage of multimedia presentations of content online. The Flash Player is available free of charge.

More information:
http://www.macromedia.com/software/flash/

Macromedia Shockwave

Macromedia's Shockwave takes the concept of Flash one step further by providing for interactive content. Webpages endowed with Shockwave content can incorporate interactive product

demonstrations, games, tutorials, and 3-D features. As with Flash, a player for Shockwave applications is available free of charge.

More information: *http://www.macromedia.com/shockwave/*

QuickTime

Developed by Apple, QuickTime is another proprietary method used to encode audio and video content. Lately, is has also been used to receive real-time content, similar to RealMedia. A basic QuickTime player is available free of charge.

More information:
http://www.apple.com/quicktime/products/qt/qt_faq.html

RealMedia

RealPlayer, distributed by RealNetworks, is a popular plug-in (application that works within a web browser) used to receive real-time audio and video (collectively, RealMedia) created with Real's proprietary software. RealNetworks offers a basic player for RealMedia files free of charge.

More information: *http://www.real.com*

TRANSLATION SITES FOR FOREIGN LANGUAGE WEBPAGES

Babelfish
http://babelfish.altavista.com

InterTran
http://www.tranexp.com:2000/InterTran

Translate Now!
http://foreignword.com/tools/transnow.htm

MUSEUMS

Thousands of museum websites await millions of you. As sheer hits, as bookstore and gift shop customers, as visitors to prime-time exhibitions, and, finally, as unique individuals seeking in visual art what the human mind has always sought: revelation . . . if not simply something different. In the last century critics and divines noted unceasingly that the art museum had replaced the cathedral as the spiritual center of society. In the new century, it seems the museum on the Web is beginning to construct a new relationship—both personal and direct—between you, me, and aesthetic revelation.

In the best of the museum websites below you are able to make your own selections about what art you wish to see and learn about. This is a very different form of "contact" with art than allowed in the early palaces and cathedrals where icons were stored for the chosen few (the museum of the "first kind") or the huge temples of mass-media populism in the last century (the museum of "second kind"). To me, it seems as though the museum of the "third kind"—which offers you a one-to-one link—is the lodestar of this book.

Not for a moment do I claim to be alone in sensing this shift. Long ago I talked with the late Louis Kahn when he was designing the lovely Kimbell Art Museum in Fort Worth, Texas. He hated big, cavernous museums because they tired him, he grumbled, and rarely allowed him a chair to sit in while viewing art. In its intimate meditative spaces, the Kimbell is a premonition of what is coming.

So are the endless string of small "project" galleries threading through "alternative spaces" and contemporary art museums. So

is Beatrice von Bismarck's prophetic essay about the rising importance of the living artist's archive, where you can get your hands on the life of art-making in letters, notes, sketches, and plans. So, finally, is Victoria Newhouse's recent focus in her writing on small museums dedicated to a single artist or collection.

Now you, too, through this guide, can join this third revolution.

GALLERY AND MUSEUM GUIDES

Art Museum Network (AMN)
http://www.amn.org

"The world's largest and most prestigious museums . . . provide free access to information about their collections, exhibitions, and services," we are told on the homepage. But this introduction downplays the vital potential of this site as a portal to a wildly active international museological network. Rightly conceived, the AMN site would give us an overview of trends and directions in museum exhibitions, policy, and design. Thanks to Intel you can buy tickets here to any of the member institutions.

The site also provides quick links to the Art Museum Image Consortium (a subscriber-based search engine providing access to more than fifty thousand works of art), exCALENDAR (the "official exhibition calendar of the world's leading art museums"), and the Association of Art Museum Directors. Highlights of current exhibitions are available directly from the AMN homepage.

Gallery Guide
http://www.galleryguide.org/

Gallery Guide is a non-profit publication that has been serving the art community for over thirty years. The online companion to the free guide is searchable by gallery, artist, location, or exhibition. In addition to finding out the latest in the topics of Gallery Highlights, One Person Shows, News &

Reviews, and Openings, explore Special Editions for issues dedicated to photography, art on the internet, and art hotspots, like Santa Fe and New York. *v.c.*

Museums of Russia
http://www.museum.ru

Museums of Russia is the largest Russian/English resource on Russian visual culture, as reflected in their newly resurgent, uncensored art museums, galleries, and online magazines. You will be pleasantly surprised to learn you have the option of hearing music as you browse. You can check out shows and collections in Moscow (the Tretyakov, among others, dedicated mostly to the art of this century with lots of baroque Stalinist realism as

well as the defiant avant-gardes of the 1920s, 1970s, and early 1980s) and St. Pete (including the glorious Hermitage). There is even a museum cafe with online repartee about everything from Greek to late nineteenth-century Russian art to Mayakovski, Tatlin, Rodchenko, and Kabakov. Occasionally infuriating, this site reveals a welcome desire to stroke and welcome the user-consumer. *N. Z./V. S.*

MuseumStuff.com
http://www.museumstuff.com

Launched in 1999, MuseumStuff.com has a lot of stuff to ponder. It's a dizzying information center for thousands of museums. From the Art and Design section you can delve into Art Museums, Architecture, Photography, Virtual Exhibits, Ancient Art, Artists Online, and Art Fun. The Showcase reviews websites that MuseumStuff.com deems "exceptional." Forget searching individual museum pages: a recent visit to this site offered 224 alphabetically-organized links to online art exhibits. Scroll to the bottom of the homepage for quick bites of museum websites that you never even knew existed.

Virtual Library Museums Pages
http://www.icom.org/vlmp/

A subsection of the International Council of Museums website, this is a directory to all major international museums and links to strictly online exhibit sites like the WebMuseum and the Artchive. Like any library, it doesn't flaunt flashy design, but it's an incredible, seemingly unbiased listing of museum and gallery URLs organized by country. You can also browse by category: International Museums, Galleries, Libraries, Books (a quick link to vital and occasionally expensive artist and museum catalogs through Amazon) and Children (a virtual museum just for the tykes). *V. C.*

THE LOUVRE AND ITS OFFSPRING

The Art Institute of Chicago Chicago, Illinois
http://www.artic.edu/aic/

Lively and easily navigable, Chicago's premiere museum needs only a shade more intensity to match international rivals such as the Tate. You can pop right over to online exhibitions like "Beyond the Easel," which focuses on the paintings of Bonnard, Vuillard, Denis, and Roussel. Often you get more input here than any museum walkabout lasting less than a day. With lesson

plans and recommendations for art projects, Art Access moves kids and teachers swiftly through most areas of the collection while Art Games offers twelve child-friendly games (as long as you have Shockwave and QuickTime) that indulge the digital medium more than the rest of this comfortable site. But the real heart here is the Collections page where you can explore the work of Arshile Gorky, Eugene Atget, Joseph Cornell, Gerhard Richter, and company.

The British Museum London, England
http://www.thebritishmuseum.ac.uk

Here you find one of the earliest institutions that resembled what we now call a "museum." The big British Museum has been offering its treasures to a wide swath of citizens since 1753. Now, its hip, labyrinthine website takes you back through the art, natural history, and inventions of many ancient world cultures. Click on Explore to see the artifacts of India, Japan, Egypt, and other countries. The searchable COMPASS database will whip you through three thousand objects selected from this mammoth collection. Navigate provides

an intuitive sitemap and an overview of this infinitude of knowledge or jump to Challenge for a host of interactive features empowered by Shockwave.

The Detroit Institute of Arts Detroit, Michigan
http://www.dia.org

This site is rich in content, but short on style, virtual tours, and interactivity. It's still worth a visit, if only to see the Diego Rivera Archive. Asian, African, Oceanic, Ancient, and New World Art—they are all admirably, if stolidly, presented. But to find buried

treasure, click on the Museum Information link to uncover the museum's searchable and illustrated collection database. The department of graphic arts brags like P. T. Barnum ("More than twenty thousand works of art on paper . . ."). But hey, this is not only the USA: it is Detroit, where Henry Ford ruled out understatement forever.

Fine Arts Museums of San Francisco
San Francisco, California
http://www.thinker.org

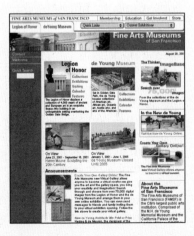

Imagination almost runs amok here. This digital thinker melds the programs and collections of the de Young Museum (American paintings; decorative arts and crafts; arts from Africa, Oceania, and the Americas; and Western and non-Western textiles) and the Legion of Honor (European decorative arts and paintings; Ancient

art; and one of the largest collections of prints and drawings in the United States). Rodin's *Thinker*, in the collection of the Legion, is at once a functional object of study and the name of the sumptuous ImageBase which allows easy access to seventy-five thousand images. With the assistance of Shockwave, you're given the opportunity to select and organize any group of these images into your own "museum," then post them online for others to compliment or contest. The Current Exhibitions link not only shows you what's current but often provides online-only exhibition supplements. Let the tired, sleepy board members of other museums open their eyes and seek out this website as a model!

The Fogg Art Museum Cambridge, Massachusetts
http://www.artmuseums.harvard.edu/fogg

If you can't visit Harvard University's oldest art museum in person, you can travel there on the Web to examine its meticulous online exhibitions. You may find yourself "Investigating the Renaissance" by means of X-ray photography. Here you can burrow deep into *The Last Judgment*, a mystical vision of the airborne Christ by fifteenth-century Dutch painter Jan Provoost. Or you can contemplate a bemused Virgin cradling her infant (*The Virgin and Child*, Workshop of Dirck Bouts, c. 1460) as you virtually uncover layers of paint and catch every swipe of the brush. Featured Exhibitions is the port of call that transports you to a collection of paintings by the forgotten Ben Shahn, a modern painter

who cared about content. Finally, for a special treat, visit the Past Exhibitions to gain access to a highly searchable database of images and text inspired by the mellifluous John Singer Sargent,

who is pure style and no content. But we all need an esthetic vacation now and then . . . don't we?

The Frick Collection and Frick Art Reference Library
New York, New York
http://www.frick.org

Founded in the last century by Pittsburgh industrialist Henry Clay Frick, this museum in a small New York mansion centers on Renaissance and nineteenth-century art. The website gives you swift and unique access to the biographies of the artists it favors, as well as images of their work, plus links to current exhibitions. Your virtual tour of the galleries comes with RealPlayer audio narration by the collection's director.

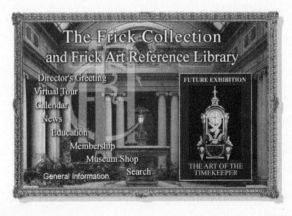

J. Paul Getty Museum Los Angeles, California
http://www.getty.edu/

The Louvre, the Met, and all the rest of the art Godzillas face severe competition from the Getty, which not only seems determined to outentertain them ("the mission of the . . . museum is to delight, inspire, and educate a diverse public . . ."). By the

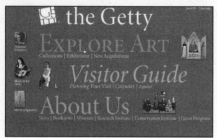

looks of the New Acquisitions page, the Getty also seems to have outbid other museums on a regular basis. Not long ago, these additions to the collection included a delightful Monet cathedral captured in the morning light, a van Gogh drawing created during his late period, and a rare photograph by Roger Fenton of an antic nineteenth-century billiard hall. Speaking of photographs, the Getty also packs a mighty collection of these. Having lately transformed itself into one of the easiest video viewing portals in museumdom, it is offering the voice of Walker Evans talking about the Depression over a stream of his images. Sure, the Getty is serious. This site is filled with evidence of its sober research, grants that encourage the use of technology in education and in conservation, etc. Hollywood seems to lurk behind every profound move the Getty makes. Remember the egomaniacal self-promotion of the monarchs, kings, and tycoons who preceded Mr. Getty, our own homegrown tycoon.

Kimbell Art Museum Fort Worth, Texas
http://www.kimbellart.org

Architecturally the finest small museum in the United States, the Kimbell is the masterpiece of the late Louis Kahn. Its virtual presence competes beautifully with the real thing, offering rare intelligence in the text and imagery that represents

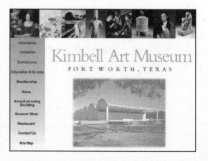

the classical collection (from traditional European still lifes to Oceania and antiquities). Here, as at Harvard's Fogg Museum, X-ray techniques allow you to see through paintings. The simple, searchable database lets you access any artist, work, or medium quickly. And, with QuickTime, you can "stroll" the galleries. There are no online exhibitions yet, but let's hope they're on the way, friends.

Louvre Paris, France
http://www.louvre.fr/louvrea.htm

In the late 1700s a gang of rowdies seized the king's private art galleries in the name of the French revolution, provoking Edmund Burke and others to predict the death of fine art. However, the artist Jacques-Louis David, who demanded and got a hand in running the transformed palace which opened in 1793, stated the contrary. "Now . . . the public . . . shares a portion of the riches of genius," he declared. "Their understanding will increase; their taste be formed." Despite decades of gross negligence (the Louvre waited until the 1980s to clean and reorganize its basement of icons), David's prophecy proved correct. Thanks to architect I. M. Pei, the liberated, once-grimy Louvre is now a delight to visit. (Go to *http://www.louvre.fr/anglais/visite/ vis_d.htm*, click on Pyramid and sail around Pei's redesign.) Millions now

throng its once patrician galleries, many standing in long lines to see the Mona Lisa or Courbet's risqué masterpiece *Center of the World*. Online you can explore most of the collection with QuickTime VR. You can also take one of fifty virtual guided tours, which can be paused, reversed, or advanced, much like a VCR. No, you won't be encouraged to see current exhibitions on this URL, few which can match the collection launched by the despised king anyway.

The Metropolitan Museum of Art New York, New York
http://www.metmuseum.org

After drowning us for years in turgid, dull homepages, the august Met is now racing with the wind. Everyday a different work of art greets you. Click on the image to be taken to the main directory, where you are assaulted with an overly athletic array of competing attractions. Clicking on Special Exhibitions is like diving into the deep, but what else is to be expected from the magnificent museum monster? And with over 3,500 works as of mid-2001, touring the Online Collection is barely manageable. In the same vein as the Fine Arts Museums of San Francisco website, the Met allows you to design your own gallery of faves, but first you have to sign the guestbook. One Special Exhibitions feature allows you to trade your email address for an electronic reminder about new shows. And kids will find lots of fun art games in Explore & Learn. After a deep sleep, the Met is finally waking up to its online life.

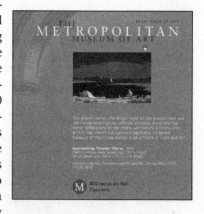

The Minneapolis Institute of Arts
Minneapolis, Minnesota
http://www.artsmia.org/

As our best tabloid headlines like to say, this site is a real shocker. The Minneapolis Institute of the Arts begins with a bland homepage (too many images and too much hype for Join, Shop, and E-Postcards), but it packs a hidden punch. For a textbook lesson in interactivity, click on the "Modernism" exhibit (see Online Educational Projects in the Education section). Beginning with a clear outline of its five major component movements (Arts and Crafts, Art Nouveau, Wiener Werkstätte, De Stijl, and Art Deco), modernism is stripped bare for you here. Explore each section to be seduced by design and imagery. Drop into Movies for videos of Design Curator David Ryan walking you through the show. You can hear more from the ubiquitous Ryan in Curator's Corner, where allegedly you can dialogue with him, too (if not an intern pretending to be him) by leaping over to Comments, a feature avoided by most higher institutions. QuickTime 360-degree viewing of 250 objects is another unexpected find. Yes, this site has been massaged far too much by commercial design, but it's still welcome.

Musee d'Orsay Paris, France
http://www.musee-orsay.fr

A national fortune was spent in the 1980s to open this imperious museum of nineteenth-century art in an immense old converted

31

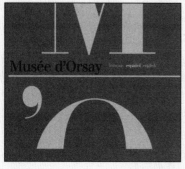

train station, but not a franc seems left over to employ either intelligence or imagination on its website. The content is brief and uninspired. The Collections page offers a paltry gathering of works with flat, one-paragraph descriptions. The New Media section simply offers a photograph of an on-site computer lab and a text overview of the museum's new media initiatives, but nothing more. You won't even see much of the current exhibition—you'll just be invited to hop on a plane and come on down. Mainly, this URL is a poster for the train station muse. You are better off ogling the d'Orsay collection in an alternative virtual guide to Paris: *http://www.smartweb. fr/orsay.*

Museum of Fine Arts (MFA) Boston, Massachusetts
http://mfa.org

Get past the typical aspects of another institutional website—this time featuring the beaming director, Malcolm Rogers, as well as an icon of a leather jacket icon urging you to "Shop Online"—and once again you will find great online content. Check out the Giza Archives Project (see the

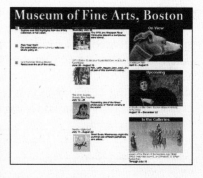

Collections page), a bravura display of the ancient Egyptian Giza Pyramids funded by an enlightened grant from the Andrew W. Mellon Foundation. In the early 1900s, the MFA joined with

Harvard University and scholar George A. Reisner to dig up a swarm of treasures, most of which you can now survey online with Augustan ease. What is really fascinating here is that you can see the handwritten notes made by the excavators on the exact day the object was unearthed. This online archival project is constantly updated so the flood of images grows month by month. The quantity and profound quality of the Giza Archives makes the rest of the MFA's offerings seem bland. But it puts the competition to shame as well.

National Gallery London, England
http://www.nationalgallery.org.uk

This is the newly designed URL for a gallery launched in 1924 when the House of Commons bought thirty-nine paintings. In Collections, you can sample a treasury of Western European art between 1260 and 1900, which you can access through symbolic imagery and sub-heads like Art in Science. Or let the Collection Explorer lead you by the hand, from van Eyck's famous *Portrait of Giovanni Arnolfini and his Wife* to Seurat's *Bathers at Asnières*. But the most imaginative Web feature is the link to the EuroGal-

lery search engine (*http://www.eurogallery.org*), which we found tucked away on one of the Collection pages. EuroGallery allows you to sweep the collections of six major museums, including the Louvre, the State Hermitage Museum, and the van Gogh Museum. Type in an artist's name and you'll be rewarded with a list of links. For example, we found 172 links for Brueghel. Not bad.

National Gallery of Art (NGA) Washington, D.C.
http://www.nga.gov

Of the nationally sponsored galleries, NGA ranks among the least
turgid. The painting featured on the homepage changes daily (at
last this is becoming de rigueur for a once sleeping genre), but
more importantly, The Collection page offers you a different tour
each week (for example,
"African-American Artists"
or "Romantics and Real-
ists") and it's girded by a
giant database offering
links to almost everything
else the gallery owns.
Under Online Tours you
can further sample almost
any major artist or genre,

from Rembrandt and Pollock to fauvism and still lifes. Animation
abounds on the NGAkids page (requiring Flash and QuickTime,
which any self-respecting child between the ages of six and ten
knows how to get). The kids also get an animated musical, "Lizzy
Visits the Sculpture Garden with Gordon." A rare display of insti-
tutional collaboration between the NGA and London's Victoria
and Albert Museum makes the online tour "Anatomy of an Exhi-
bition: Art Nouveau, 1890–1914" a must-see, complete with a
time-lapse movie of the exhibit room's construction and audio
segments narrated by the NGA director. Hmmm. Perhaps the vir-
tual gallery is as much fun as the real one.

National Gallery of Australia Canberra, Australia
http://www.nga.gov.au/

It makes sense that the National Gallery of Australia was among
the first to attack the Web with a vengeance, sited as it is in a
highly wired nation far from the rest of the world. Here you will

find a huge batch of purely Australian art, some by Aboriginals and islanders of the Torres Strait. There is also lots of interna-

tional art here, particularly modern, mainly because the new Australians were linked in origin and passion to Europe and, later, America. Unique touches are sumptuous exhibitions of children's artwork (see Exhibitions page) and a vast panorama of Australian prints (see Collections page). Lively interaction? No. Total access to the work of an entire continent? Yes.

National Gallery of Canada Ottawa, Ontario, Canada
http://national.gallery.ca

Here ingenuity triumphs over a collection that can't quite match the breadth of the Louvre's offspring. The focal point of this URL (aside from the unique collection of Inuit art created by native Indians of the frozen North) is CyberMuse, the multimedia counterpart to the physical museum. Click on the CyberMuse icon to be transported to an unconventional diet of audio, video, and images representing the gallery's exhibits and collection. Often the works are paired with artist interviews (including James Rosenquist discussing everything from race relations in the 1960s to losing the family farm) or curatorial dialogues (such as the verbal

dissection of two Monet paintings). And, if you arm yourself with Quick-Time before trotting off to the Galleries, you can go on an exceptionally vivid virtual tour of the entire museum.

National Museum of African Art (NMAfA)
Washington, D.C.
http://www.nmafa.si.edu/

Part of the Smithsonian complex, this URL is simple in concept but fires off into multimedia exuberance in several areas. If you choose to view exhibitions, you will probably find yourself deep in Flash animation. An elegant recent example is "The Presence of Spirits." Organized with the National Museum of Ethnology in Lisbon, this exhibit is filled with exquisite dolls, stools, and masks created in Angola and other formerly Portuguese colonies. Past exhibitions are archived here as well, like "Claiming Art/Reclaiming Space: Post-Apartheid Art from South Africa," where clicking on any piece of art instantly offers you more info. Other long-running online delights, such as "Beautiful Bodies: Form and Decoration of African Pottery" and "The Poetics of Line," which focuses on seven Nigerian painters and graphic artists, are still worth touring and contemplating.

National Palace Museum Taipei, Taiwan, China
http://www.npm.gov.tw/

This site is a cybercelebrity. You will find yourself greeted by flute music, surely designed to seduce not only the public but also the critics and judges who have acclaimed this site. Your senses will be moved by loads of online features. Once inside any of the exhibits, like the recent "Plant-and-Insect Paintings," tiny bits of artwork can be enlarged, some guided by curatorial labels linked to a glossary of terms. The paintings in the Collection are subdivided by dynasty, so you can easily roam across many centuries.

Unlike many other sites, the palace offers you lots of free downloads, including desktop patterns, screensavers, e-cards, and calendars. It's almost too charming. We expect pain when viewing art in a museum, as the late Louis Kahn pointed out. Please get serious, friends in Taipei. Give us at least a few minutes of suffering.

The National Portrait Gallery (NPG) Washington, D.C.
http://www.npg.si.edu

Partly because this vintage gallery will be closed for repairs until the fall of 2004, and partly because the design of the Smithsonian museum websites is fiercely imaginative, the NPG website deserves must-see priority for the art-going public. The site is crammed with painted and photographed portraits you can't see anywhere else save traveling NPG shows. The interactive features are myriad

and delightful, even though you have to download proprietary software like a pro to enjoy them. Browse through the quarterly newsletter *Profile* for historical context and curatorial insight about the many portraits within the NPG collection. The virtual exhibition "A Brush with History" offers instant access to dozens of brilliantly selected faces, which occasionally shock you and more often confirm personal bias: the celebrated Dolley Madison,

for example, shows us a face weathered with wear while the stately, removed T. S. Eliot is exactly the sourpuss we'd expect.

Pennsylvania Academy of the Fine Arts (PAFA)
Philadelphia, Pennsylvania
http://www.pafa.org

Founded in 1805 by painter and scientist Charles Willson Peale, sculptor William Rush, and others, PAFA continues its support of the arts and art education with exhibits ranging from Italian masters to emerging contempo-

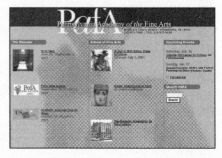

rary artists. From the homepage, check out the invaluable collection of six fragile artists' sketchbooks (Thomas Anshutz, Thomas Eakins, William Glackens, etc.) that you couldn't touch in the museum itself. You can "turn" the pages of each notebook with your mouse to see the inner self sketching, dreaming, and thinking, often with no public in mind. In addition, parents should browse their offspring through "Andy Warhol: Social Observer" (in the museum's archive of Past Exhibitions) for a witty examination of color theory and the silk-screen process.

Prado Museum Madrid, Spain
http://museoprado.mcu.es

No museum that owns Velasquez's *Las Meninas*—lately cleaned to a bright, mysterious sheen—need hang its head over an inglorious website. But somewhere in heaven, God or an angel will surely ask the current director of this treasure-house why his English translations, down to the spelling, are so bad. A hard site

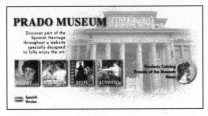

to navigate, but the Visits page almost saves the day. Here you are offered a virtual gallery tour of fifty choice *pinturas* (including the mystical *Las Meninas*, where you find yourself being stared at by Velasquez himself as he looks beyond the royal family in the forefront and directly into your eyes), a monthly focus on "One Work, One Artist," and a searchable database of three hundred works.

Smithsonian American Art Museum Washington, D.C.
http://www.americanart.si.edu/

The Smithsonian American Art Museum, which operates entirely as a virtual museum while its main building is being renovated, has always been the fearless brat of the Smithsonian system of museums, galleries, and libraries. Right now you can "view over 4,000 images" from the permanent collection or taste endless interactive delights, including: Ask Joan of Art (who answers your emailed art questions); Inventories of American Painting and Sculpture (which documents more than 300,000 objects in public and private collections worldwide); Helios (an online photography center that also focuses on new media);

Kids' Corner ("an interactive art activity room"); and *¡del Corazón!* (a bilingual Latino art webzine for teachers and students). Last time we visited the site there were sixteen virtual exhibitions and 5,000 easily called-up objects from the permanent collection. 'Tis no wonder this hugely ingratiating complex of digitalia rouses more hits and users than almost any other site in the museum field. Maybe it will overwhelm rather than inspire some of you, but it's still a mellow, mellow stop.

The State Hermitage Museum St. Petersburg, Russia
http://www.hermitagemuseum.org/html_En

This is the winter palace once inhabited by emperors that fell to the Bolsheviks in 1917. Now, three hundred years or so after its renovation, the Hermitage holds roughly 3 million works of art. Best of all, its sophisticated URL, informed by IBM consultation and software, makes the tracking of the art and galleries possible. Smart-faced Query by Image Content is almost too clever for its own good; in addition to the standard search criteria, you can call up a work of art by choosing a color from a palette or sketching its outline on a digital "canvas." The Zoom View feature of the Digital Collection is superb; try it and note all the delicate details you find. Finally, by way of virtual tour you can explore not only the galleries, but even take a walk outside the museum on the banks of the Neva River, where the Bolsheviks hid until the call came to storm a fortified palace that turned out not to be fortified at all.

Tate Collections
http://www.tate.org.uk/

Usual intelligence girds this site. It's a foray into making a website that exists primarily as an interactive agent with your keyboard, rather than as flagship for "real" exhibitions occurring elsewhere. From this site you can link to all the Tate websites, including the Tate Britain and Tate Modern. But here you can stay seated and joyfully select from a collection of twenty-five thousand works ranging across a considerable span of time. Go right to Collections and type in almost any artist, work, or subject and usually an image plus information pops up on the screen. By 2002, the Tate site promises to expand to fifty thousand items, its entire collection. In the meantime, this is one place where the viewing is under your control. Most of the time if you click to increase the size of the image . . . it does unfold.

Victoria and Albert Museum London, England
http://www.vam.ac.uk

The neat homepage honors the beauty of simplicity by offering you nine small square images which, when clicked, zap you instantly to the place portrayed. Yes, smooth design ought to be expected from this central clearinghouse of decorative art, but it's still welcome. The V&A is deftly pushing the interactive edge. You can create a virtual Mughal tent, download an educational booklet about Constable, wallpaper your PC's desktop, and send your friend, enemy, or lover an e-postcard. The museum is also home to the Canon Photography Gallery. No, the

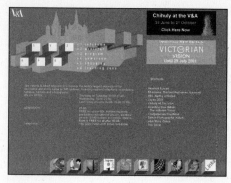

V&A doesn't ignore the high, fine arts, particularly in its treasure trove of prints. Finally, the V&A will soon offer another radical departure: the daring geometry of its Spiral gallery, designed by Daniel Libeskind (see THE ARCHITECTURE OF THE MUSEUM for his URL) and destined to whirl around a small space between two traditional buildings in the blinking center of Old London.

THE MUSEUM OF MODERN ART AND ITS ALLIES

Centre Pompidou Paris, France
http://www.cnac-gp.fr/

When Pompidou finally opened all its ramps and elevators in 1978 it brought the traditional view of what a museum could be to a definite end. MOMA in New York,

the Museum Sztuki in Poland, and various modernist gestures in Moscow began the challenge in the 1920s and 1930s. But Pompidou, with its anticlassical architecture and vigorous commitment to contemporaneity, finished the job. From the outside it appeared —with its brash colors and technocratic trappings—to

be a King Kong of New Style Pleasure, not a refuge for reflection and meditation. A click on the Museé link will take you to an interactive floor plan. Pompidou is jammed with new forms of art and a hectic exhibition schedule. Sure, online you can tour new exhibitions—devoted to Kandinsky, say, with a collage of brilliant photos as well as paintings. You can invade a bulging database to find out all that is stored in this monumental warehouse. But you can only do these things in French—unless you equip yourself with the URL address of a translation service such as those recommended in this book's introduction. The passion and imagination of the 1970s has cooled down. Now it's time to revive the virtual Pompidou for a new century and a different, cyber-based culture.

George Eastman House International Museum of Photography and Film Rochester, New York
http://www.eastman.org/

The man who founded Eastman Kodak, the most famous photography business in the world, also created one of the first major museums devoted to his medium. This collection is jammed with four hundred thousand images by more than eight thousand artists; after browsing the online galleries, Ask the Curator if you have a question about any of them. Go to the left side of the homepage, click on Photography Collections and watch a ghostly, fascinating video that shows how the camera was invented. With QuickTime you can even watch some ancient stereoscopic images plus early motion pictures (Education & Research link). This is not a brilliant site but it is basic (rather like the first thick

steak we eat when we land in Texas) and the exhibitions change all the time. And hey, Ansel Adams's *Moonrise* is here, one of the first truly famous single images that collectors bid for at auction. How did he catch the moon at that exact moment in the dessert? Once the great man told me at the Algonquin Hotel, but he swore me to secrecy.

Guggenheim Museum
http://www.guggenheim.org

A busy gateway greets you here, offering you links to a global empire that includes New York, the mighty Guggenheim in Bilbao, the Peggy Guggenheim Collection (in Venice), Berlin's Deutsche Guggenheim (in collaboration with Deutsche Bank), and the Guggenheim Virtual Museum. Each site offers a different style, save the last, which, despite hefty promotion and promising, was stillborn as of this writing. Of course the New York site is lively and busy and includes Web-focused projects like "CyberAtlas," made by former stalwarts at the once rambunctious äda'web, and "Brandon," a multilayered, intensely politically correct attempt to explore "gender fusion." At Peggy's Guggenheim, you can learn a lot about her biography—and those of the artists she bought—as well as take a tour of this lovely point on the waters in Italy. The Bilbao site can't lose, simply because it fills your eye with images of sensuously beautiful architectural forms (designed by Frank Gehry—for his URL see The Architecture of the Museum), which turned this Basque city into one of the world's major tourist sites. A magnificent museum still lacking an equally magnificent Web presence.

Hayward Gallery London, England
http://www.hayward-gallery.org.uk

Though this is one of the largest temporary exhibition spaces in all of Britain, this gallery, which opened in 1968 with vora-
cious ambitions, is notoriously modest and constrained on its URL. Hey, it's not that they are undemocratic: on the Arts Council Collection page, the Hayward boldly names the guilty members of its purchase committee and reveals all the buys they made between 1996 and 1998. The Hayward does use this site to show and tell us about the paintings of the flamboyant Malcolm Morley

—as it recently told us about a big Paul Klee retrospective—but in Spartan detail. Hayward, stop hiding online.

Jewish Museum Berlin Berlin, Germany
http://www.jmberlin.de

More than half a century after the Holocaust, this building houses Europe's largest Jewish museum, focusing on the entire sweep of German-Jewish history but inevitably emphasizing the

twentieth century. It officially opened in September 2001 with an exhibition celebrating its architect, Daniel Libeskind (see his URL in THE ARCHITECTURE OF THE MUSEUM). You can see aspects of the permanent exhibition and collection at its website, which covers both the first and second floors of the museum. The dynamic virtual tour will probably be available by the time this book is published.

Museo Nacional Centro de Arte Reina Sofia Madrid, Spain
http://museoreinasofia.mcu.es/

This URL may be comparatively modest, but the institution itself needs to be known on a global basis. It is the owner of Picasso's infamous *Guernica*, painted to protest the Nazi bombing of that ancient Spanish city during World War II. In 1992, King Juan Carlos and Queen Sofia opened the renovated hospital that now houses an incredibly rich collection formerly split into parts all over Madrid. The plodding but determined site takes you through each floor of the building, unveiling the collection to you in static but moving images. Then you get to the memorable third floor, where you find evidence of "the first avant-garde movements," many of which were sourced in the work of early twentieth-century Spanish painters. (Of course Picasso was at their center, along with Juan Gris and others.) Click to the sixth floor and you'll find *Guernica* (commissioned by the valiant, defeated Spanish Republic in 1937) along with the ancient *Woman in Blue*, which dates back to 1901. This site proves the power of content: no tricks, but you won't be able to desert it once you arrive.

46

The Museum of Modern Art (MOMA) New York, New York
http://www.moma.org/

Clean, lean, mean, and smartly commercial. If you keep pushing, you will find a lot here, much of it in Online Projects (under What's On Now heading), which offers a series of works either made entirely for virtual viewing or in conjunction with "real" exhibitions. Check out Tony Oursler's "Time Stream," a highly personal "history" of the moving virtual image, or "Conversations with Contemporary Artists," audio recordings from the public lecture series. From a static start, MOMA has leaped into interactivity with projects like "Art Safari Online," where kids (and presumably adults) can use tools on the site to make their own digital works and then add them to the safari collection. You also get access to current exhibitions, various stores (of course), and the incredible MOMA collection (but not quite enough of it). One day we'll get to sample that fantastic film collection online. What's missing? The sense of wonder and outrage MOMA brought us when modernity was new.

Museum Sztuki Lodz, Poland
http://www.muzeumsztuki.lodz.pl/muzeumi.htm

One of the stars of modernism, this museum—now the oldest of the "pure" modern galleries—was formally opened in 1931 after considerable agitation by a radical band of Polish artists and students in the

1920s. They were led by Wladyslaw Strzeminski, the brilliant abstract painter allied with Kasimir Malevich, whose *White on White* (1918)—echoed on this serenely uncluttered homepage—seemed the ultimate in abstraction. But Strzeminski and others duked it out with Malevich, as you can see by visiting the Collection. Throughout its existence, the Museum Sztuki (or "Museum of Art") has kept its finger on the vanguard, acquiring seminal works by S. I. Witkiewicz (who invented surreal forms of photography, painting, and theater before anyone else in the West), Tadeusz Kantor (radical postwar theater and performance artist), Joseph Beuys, Malevich himself, and countless others. This clean URL cannot hide the glory of its content.

The National Museum of Modern Art Tokyo, Japan
http://www3.momat.go.jp/index_e.html

The rearing of this huge complex in Tokyo in 1952 was the first salvo fired in a war to take over this ancient land with museums, a new form of institution. Now it spreads over three buildings—the Art Museum, the Crafts Gallery, and the National Film Center, which harbors almost twenty thousand titles. Lots of beautiful images here, but no interaction and no sophisticated use of powerhouse Web software. Despite the museum's title, its Web presence is not only unmodern, it's not even postmodern.

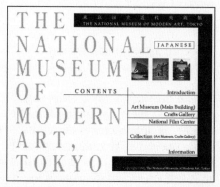

The National Museum of Women in the Arts

Washington, D.C.

http://www.nmwa.org

"This is the only museum in the world dedicated exclusively to recognizing the contributions of women artists." Once this point is made about the birth of this gallery in Washington, D.C. in 1987, the quality of the URL (which focuses on content, often political, and not on multimedia sophistication) makes sense. It takes a long time to download the complete museum tour but you can move with relative ease through links to selected artists such as Renaissance painter Lavinia Fontana, Dutch artist Judith Leyster (one of the first women to have a workshop with male artists), Camille Claudel, Käthe Kollwitz, Alice Neel, and Frida Kahlo. Finally, there's a splendid in-depth profile of the famous American artist, Mary Cassatt.

San Francisco Museum of Modern Art (SFMOMA)

San Francisco, California

http://www.sfmoma.org/

"Compact" and "total"—two words and concepts not normally linked together—define this site. It is easy to navigate, packed with information, long on Web-specific virtues (you can walk through seven key Ansel Adams works with Flash and Quick-Time as though you are inside the photographs rather than simply viewing them flat on a wall). The attention to pure online activity is intense: traditional museumgoers might feel as though SFMOMA thinks second of them, first of the Web user, a total reversal of its competitors. The Director's Welcome pays homage to its physical space, designed by Mario Botta from

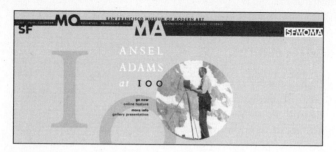

Switzerland. But the truth is his muscular factory lacks the daring present within its galleries, which consistently presents some of the most innovative modes of new art. This virtually perfect URL has a similar flaw: no grain, no roughness, no eccentricity. It's smooth, hip, and admirable, but not the provocation it ought to be.

Stedelijk Museum of Modern Art Amsterdam, Netherlands
http://www.stedelijk.nl

A lively center of innovation and the presentation of late modern art, focusing on the post-World War II period. The collection swarms over all media: paintings, sculptures, drawings, prints, photography, graphic design, applied arts, and new media. You can find almost anyone in the Net Art section, including Laurie Anderson who offers you a song originally conceived as a repertoire of the "one hundred most used words in English." But when she discovered that this left her without a lot of nouns and "men" but not "women," she had to revise her verbal strategy; read how she did it in a rare example of an artist discussing her own work. Though static, the Archives corner of this URL is golden, including exhibitions of August Sander, Dennis Hopper, Kazimir Malevich, and a collection of time-based art

(that is, audio and video). And, hey, "The Presentation: Dutch Art in the Stedelijk Palace" was curated by Queen Beatrix herself and it's not bad.

Tate Modern London, England
http://www.tate.org.uk/modern/

Though it's not perfect perfection, the Tate Modern is a near-central event in recent museum making, along with Centre Pompidou in Paris and the Guggenheim in Bilbao. Housed in the shabby, once-controversial Bankside Power Station, the Tate commissioned Herzog and de Meuron (lean, clean Swiss architects) to turn a drab turbine room into a grand welcoming space. You see all of this on a website that doesn't yet match the effrontery of the building topped by a glittering beacon light (which, alas, doesn't glow online). But Tate Modern is busily commissioning online and offline works—backed up by a public purse and a share of gambling revenues—so hold on. Watch and interact with this site. The Tate pays serious attention to content and outrage. Even a bland theme show like 2001's "Century City" pulled off lots of edgy art, writing, and history, while nominating "London 1990–2001" as the cultural equal of "New York 1969–1974" and "Paris 1905–1915." Maybe they're right.

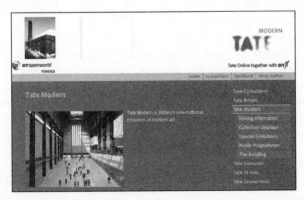

UCR/California Museum of Photography (UCR/CMP)
Riverside, California
http://www.cmp.ucr.edu/

Because it is primarily a communication medium, the Web allows small, focused museums to impact on you as totally as the gentle monsters. Here is yet another example. UCR/CMP is a museum that offers you easy access to Lucien Clerque's luscious nudes; "WomEnhouse," contemporary photos that explore the dicey politics of domesticity and gender; "wanted posters" from Wells-Fargo Internet; "Exchanges," a visual documentation of adoption; and more. Don't be frightened by all this emphasis on content. You can also surf through past exhibitions and take a historical tour of a hundred of Eadweard Muybridge's early motion studies from the last century. But you can't avoid the singularity of this contented, that is content-rich, URL.

Walker Art Center Minneapolis, Minnesota
http://www.walkerart.org

The Walker has always enjoyed forging ahead of its competition on both coasts—and did so again with its website, which has been joyously interactive for several years. Of course you can see brilliant examples of Jasper Johns, Duchamp, Hopper and other modernist icons here (you can listen to smart interviews, too). More to the present point is Gallery 9, where the Walker has been commissioning and exhibiting digital works. But the Walker is also intrepid when it comes to turning "real" events and exhibitions into virtual plasticity. One late example is the

magnificent series of video clips of twenty dance performances by Urban Bush Women (select Highlights from the pull-down menu). One last kudo: the Walk-

er shows its first face to you as a witty, one-up prankster by offering a collage of Lawrence Weiner's words which—when clicked here and there—take you to the usual institutional parade of shops, gifts, and propaganda. But by the time you get there plus download all the software you need to navigate this site, you're no longer a normal museumgoer with normal expectations. You will want more of what you have just tasted.

Whitney Museum of American Art New York, New York
http://www.whitney.org

Smart and progressive, the Whitney site lacks only soul and intellectual depth. If you download groovy software (Flash, Shockwave, and RealPlayer), you can take an exhaustive tour of the monumental "The American Century" exhibit. This rare historical treat was mounted at the Whitney in 2000. Alas, the page for the provocative "Whitney Biennial" that followed "Century," (featuring Hans Haacke's political roasting of New York

Mayor Rudy Giuliani) is mostly deconstructed. "American Voices," is a tour of works in the collection that allows you to hear the voices of both artists and curators—a neat match. The museum's adventurous move into Web-based art is mostly available at Artport, where you can occasionally roam across new works, some of which offer live webcam voyeurism. "Mies in America," companion to MOMA's hosting of the seminal architect's work in Berlin, is clean and crisp in design, befitting a master whose copious soul also escaped notice, both now and then. The interactive possibilities here are minimal, but the Whitney's virtue has always been a fast-moving surprise. Let us wait a few minutes for the next radical turn in its road.

CONTEMPORARY ART AND ALTERNATIVE EXHIBITION SPACES

Centre for Contemporary Art (aka The Castle)
Warsaw, Poland
http://csw.art.pl

Lawrence Weiner twits this huge structure with an inscription: "Far too many things to fit into so small a box." Well, far too many things has defined the Castle since its takeover by insurgents and independents of this palatial manor, which once housed both royalty and Communist party bureaucrats. Now it houses and feeds artists and gives them romping room for every new form of art, including photography, film, video, and Web-based variations. If you don't read Polish—and can't gain access to one of the free online translation services noted in the front of this book—you may

not be able to follow all the art openings, film screenings, and other events. But you can sure enjoy the anarchic imagery here. For a taste of fierce Polish political resistance to every ideology, left and right, check out the exhibition of documents, photographs, performances, and texts by Elzbieta and Emil Cieslar, dissidents who fled Communism in the 1970s for France but stayed in touch with underground Warsaw, Lodz, and beyond. They are self-styled "angelic Anarchists" out to define "the wild left" in a variety of formats.

Center for Art and Media Karlsruhe, Germany
http://on1.zkm.de/zkm/e/

(See entry under NEW MEDIA AND INTERDISCIPLINARY ART.)

Dia Center for the Arts New York, New York
http://www.diacenter.org

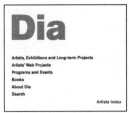

Gently hiding its radicalism, one of the most adventurous art institutions in the world opens on a sweet white page, offering a simple directory that belies the content you will find there. It includes not only news of current exhibitions but documentation for all artists that have been exhibited or supported by Dia. Here you will find Walter De Maria's epic *The Lightning Field* and *The New York Earth Room* piled with esthetic dirt, James Turrell's *Roden Crater* in Arizona, and Andy Warhol's *Last Supper* paintings. Most of all it harbors a thick nest of Net art projects, which Dia has been promoting and collecting since the genre first emerged. They can include the offer of a digital flower by David Claerbout to sprout, delight, and die on your computer terminal plus a sound concert by Stephen Vitiello that mixes the noises made by mating fruit flies and an underground volcano. This site is highly recommended.

The Institute of Contemporary Arts (ICA) London, England
http://www.ica.org.uk

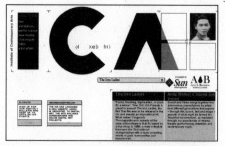

A lively center for art, controversy, media, and discussion, but the ICA website pretends to be an old lady. The site is mainly a calendar of events designed to bring you through the front door—the classic mistake usually made by exemplars of tradition, not radical beehives like the ICA. However, you can see some online digital projects at the institute's New Media Centre page and you can link to lots of new films either shown at or recommended by the ICA. Not long ago the institute got frisky and offered us a "Cellular Pirate Listening Station" devised by irational.org. Just what the Brits and many of us stiff Westerners need: a radio scanner in central London that picks up pirate signals throughout the region and rebroadcasts them to the world via the Net. Long live the revolution!

Lehman College Art Gallery Bronx, New York
http://ca80.lehman.cuny.edu/gallery/web/AG

Though its exhibitions range across the ages, this gallery is cutting-edge contemporary no matter what content is on display. The first institution to commission an entirely new work of Web-based art (*The World's First Collaborative Sentence*—see NEW MEDIA AND INTERDISCIPLINARY ART for full description), Lehman has since commissioned a wide range of Web and performance projects, including *TalkBack! A Forum for Critical Discourse*, one of the first serious online media art journals edited by Robert Atkins, and digital installations by Adrianne Wortzel (Quick-

56

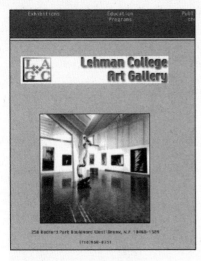

Time required). All of this raw, breaking history can be accessed through the Lehman URL, along with exhibitions (provocative on the level of content alone). See Anaida Hernandez's 1997 installation *Hasta Que La Muerte Nos Separe* ("Till Death Do Us Part") that deals vividly with domestic violence from the perspective of a Caribbean woman. In 2001, Lehman devoted its galleries to the murals, collages, drawings, and paintings of Lisa Corinne Davis, an African-American artist determined to deconstruct what she calls "the notion of cultural purity," black or white, as an "artificial simplicity." In the heart of New York City's teeming multicultural Bronx, this gallery speaks to the entire world on a series of challenging levels.

The Museum of Contemporary Art (MOCA)
Los Angeles, California
http://moca-la.org

Feisty and self-confident, MOCA has brought daring architecture to the design of three contemporary gallery spaces— its main terminal designed by Arata Isozaki in a witty postmodern style, its warehouse-style gallery by Frank Gehry, and its West Hollywood venue

designed by Cesar Pelli & Associates. This URL packs wit and printer-friendly essays on current shows. Best of all, MOCA's Portal is filled with news, resources, and links "to the best of the web." Its Digital Gallery is just beginning to feel its oats, having launched itself with *Still Life, Choosing and Arranging* by John Baldessari, by now the Rembrandt of the Cool California Conceptual style.

New Museum of Contemporary Art New York, New York
http://www.newmuseum.org

A virtual shadow of the exuberant reality housed on Broadway near the northern border of Soho. Here on the Web you are ambushed mainly by lively and verbal text linked to neatly spaced icons, not powerful imagery. You are largely told about the ingenious exhibitions, without a virtual reality tour, interaction, or pure online content. But if you are a teen or younger you get all these goodies in the museum's Visible Knowledge Program (VKP). This interactive site offers downloadable curricula, online classrooms, a look at artists' and students' studios, and library links. You can also join online dialogues with students and educators abroad. But hold on—the new Media Z Lounge, focusing on the digital arts, opened this summer: a new turn for the New Mu.

P.S.1 Contemporary Art Center New York, New York
http://www.ps1.org

Nestled in a converted, historic public school building, the P.S.1 Contemporary Art Center is an immense outpost of pleasure in Queens, just one subway stop from Manhattan. At this virtual

P.S.1 MoMA

outpost, contemporary obsession with participation and interaction is allowed full reign: join online forums with artists and art professionals, enter the artist-run Lecture-Lounge, watch videos, assist with language translations for online works, and view (and play with) P.S.1's past and current exhibitions. Satan bless the minimalist P.S.1 homepage for its brutal, joyless simplicity, but, past this grayscale gateway, there is plenty of detailed and vivid imagery. Shop, check out current events, learn about the center's Studio Program (from its birth P.S.1 has offered studio space to international artists), and more.

THE ARCHITECTURE OF THE MUSEUM

The design of this fast-breaking, fast-moving building form—which is already taking on nonmaterial forms, such as the URL—is more than a new type of artistic expression. It also functions as a tabula rasa of social and political desire, as well as an esthetic need (its traditional use). Certainly we are moving into what I have already called "the museum of the third kind," which reaches out to a far wider and more complex public than its first- and second-kind parents (the royal collections hidden away in castles and the populist megaliths of our own time). The second-kind exemplars include Centre Pompidou in Paris and the network of gleaming Guggenheim museums ringing the world. But neither can fully satisfy the immense audience of individuals who visit their URLs, or the developing desire for small institutions that focus on specialized genres, artists, and media. Visit the URLs of innovative museum architects like Frank Gehry, Daniel Libeskind, Steven Holl, Frederick Fisher, and the Swiss team of

Herzog and de Meuron to get a sense of this move toward the creation of modest but complex, interactive spaces. Gehry's design for the Ohr-O'Keefe Museum in Biloxi, Mississippi, a decentralized grouping of small galleries spread across a one-acre green plot, may be a sign of a radical shift toward a century when museums regroup to serve the single, not the mass, mind. But don't overlook the great designers gathered below whose work brought them to this point.

Alvar Aalto
Alvar Aalto Foundation: *http://www.alvaraalto.fi/*

Peter David Eisenman (projects include Wexner Center for the Visual Arts and Aronoff Center for Design and Art)
Biography (from archINFORM):
http://www.archINFORM.net/arch/ 1073.htm

Frederick Fisher and Partners (projects include Berlinische Galerie, P.S.1 Contemporary Arts Center, and the Eli Broad Foundation)
Official website: *http://www.fisherpartners.net/*

Frank Gehry (projects include Bilbao Guggenheim and Vitra Design Museum)
Gehry exhibit at the Guggenheim Museum:
http://www.guggenheim. org/exhibitions/gehry/
Unofficial website: *http://www.frank-gehry.com/*

Jacques Herzog and Pierre de Meuron (projects include Tate Modern and Köppersmöhle Museum)
Biography (from The Pritzker Architecture Prize site):
http://pritzkerprize.com/2001anncadv.htm
Herzog and de Meuron exhibit at Walker Art Center:
http://herzog_demeuron.walkerart.org/

Steven Holl Architects (projects include New York's Museum of Modern Art and Helsinki's Museum of Contemporary Art)
Official website: *http://www.stevenholl.com/*

Koolhaas (projects include Kunsthal Rotterdam)
Biography (from About.com):
http://architecture.about.com/msubarc-k.htm

Daniel Libeskind (projects include Victoria and Albert Museum and Jewish Museum Berlin)
Official website: *http://www.ooo.nl/libeskind/*

Fumihiko Maki (projects include Kyoto's National Museum of Modern Art and Tokyo's Spiral Building)
Biography (from The Pritzker Architecture Prize site):
http://pritzkerprize.com/maki2.htm

Richard Meier and Partners (projects include High Museum of Art and Frankfurt's Museum of Decorative Arts)
Official website: *http://www.richardmeier.com/*

Renzo Piano (projects include Centre Pompidou)
Renzo Piano Workshop Foundation: *http://www.rpwf.org*

Richard Rogers Partnership (projects include Centre Pompidou)
Official website: *http://www.richardrogers.co.uk/*

Peter Rose (projects include J. B. Speed Art Museum and the Canadian Center for Architecture)
Homepage (from Harvard's faculty pages):
http://www.gsd.harvard.edu/faculty/rose/

Skidmore, Owings & Merrill LLP (projects include Sioux City Art Center)
Official website: *http://www.som.com*

Kenzo Tange (projects include Yokohama City Museum and Hiroshima Peace Center)
Biography (from The Great Buildings Collection website):
http://www.greatbuildings.com/architects/Kenzo_Tange.html

Yoshio Taniguchi (projects include Nagano and Toyota Municipal Museum of Art and the expansion of New York's Museum of Modern Art)
Official website (Japanese language site—you will need to use one of the translation services listed in TECHNICAL NOTES):
http://pec.shinshu-u.ac.jp/tany/

Frank Lloyd Wright (projects include New York's Guggenheim Museum)
Frank Lloyd Wright Foundation:
http://www.franklloydwright.org/

Other comprehensive URLs dedicated to architecture:

archINFORM
http://www.archINFORM.net/

The Great Buildings Collection
http://www.greatbuildings.com

The Pritzker Architecture Prize
http://www.pritzkerprize.com/

NEW MEDIA AND INTERDISCIPLINARY ART

Since early in the last century the destiny of art has been to blast between the disciplines, taking shards of them into outer space—that is, into new, improbable forms of artmaking. When the Bauhaus opened in 1919, its manifesto called upon architects, sculptors, and painters to take up "the crafts"—tools and media never associated with the fine, high arts such as welding, electricity, plastics, etc. But in the new century nothing is fine or discrete/discreet, everything is impure, thanks to the keyboard I'm using as I type this. These words will soon spray out over the Web as well as etch into paper, to be downloaded and transformed in ways none of us can imagine. "New media" is the perfect term to envelop the edgy results of interdisciplinary art in the new century, which leaves the Bauhaus tools buried under their revered dust.

New media not only refers to the Web or software that adds imagery, sound, and touch to your monitor. It means moves we don't know much about yet but simply forecast or apprehend: mini-computers on the wrist or in your hand (Palm Pilot movies are a beginning here), software that talks with and touches you, perhaps cloning your voice, and museum and gallery installations that change color, shape, and sound before your eyes. For all of these reasons, this section is not only the hottest in the book but the one that will constantly evolve. It's also the most diverse in its demographics, incorporating museums, "alternative spaces," colleges, media centers, and individual artists—well that is what "interdisciplinary" means. Stay tuned!

0100101110101101.org
http://www.0100101110101101.org/

"010101: Art in Technological Times"
http://010101.sfmoma.org
http://www.artmuseum.net/01/page.html

At one minute after midnight on January 1, 2001, the San Francisco Museum of Modern Art (SFMOMA), in collaboration with Intel and ArtMuseum.net, launched "010101: Art in Technological Times." The ambitious and thought-provoking exhibition debuted online with five Web-based commissions. Over two dozen installa-

tions, video works, sound pieces, and digital projects, as well as examples of more traditional art mediums which originally appeared in the SFMOMA galleries, are also on view here. The exhibition includes recent and commissioned work by some thirty-five contemporary artists, architects, and designers from North America, Europe, and Asia who are responding to the world charted by this book, a world definitively altered by the increasing presence of digital media and technology.

äda'web
http://adaweb.walkerart.org/

Along with Rhizome and ArtNetWeb, this site, which owes its name to Lady Ada Augusta Lovelace, daughter of the mercurial

nineteenth-century poet Lord Byron, proves how powerful a collective of artists can be when they pour their energies into the same vial of wine. Now archived by the Walker Art Center, äda'web was founded in the 1990s by Ainatte Inbal, Andrea Scott, Ben-

jamin Weil, Cherise Fong, and Vivian Selbo. You see here how they detonated artists and museums all over the Web in sections like Context (ripe with info and biographies of all contributors), Exchange (a lively, though now closed, store offering art products), and Usage (links to hip simpatico URLs). On the homepage you're greeted by a scrolling stream of artists' projects and a slender pull-down menu at the top which can take you to a hypernarrative by Doug Aitken and a classic text by Jenny Holzer that sums up Lady Ada: TIMIDITY IS LAUGHABLE.

Alternative Museum New York, New York
http://alternativemuseum.org

One of first brick and mortar museums to go virtual (read Matthew Mirapaul's review, "Museum Goes Virtual," in the

New York Times, May 2000), it presents online digital exhibitions and commissions artists to create new Web-based work. Digital exhibitions include works by Mark Napier, Jon Ippolito, and Wang Qingsong. One of the first new paradigms of online publishing, *Tam Monitor* is the museum's electronic journal of contemporary art that includes: live webcast events; streaming net radio; downloadable mp3s; streaming audio and video interviews and documentaries; Web-based works bridging performance art and activism; alternative Web browsers; and reviews of contemporary art exhibitions. The Alternative Museum is a featured digital museum on the Whitney's Artport website. *C.W.*

Mark Amerika
http://www.altx.com/main.htm

His Alt-X Press hits the margin of thinking about how to write (or publish) on the Web. "What Is Literature's Exit Strategy?" he asks. You can download Palm Pilot texts from here and more. If you want to learn "How to be an InterNet artist," read his column and taste his latest online exhibition—at this writing it's "Avant-Pop: The Stories of Mark Amerika." Nobody can beat him for the art of titling. We'll tell you more about Alt-X Audio elsewhere, but don't forget you can hear, as well as see, Amerika.

Ars Electronica Center Linz, Austria
http://www.aec.at

One more example of European generosity and patronage toward new media is here, where, since 1996, artists have been routinely invited from around the world and offered high-grade technological lifelines to studios and tools as well as festivals,

conferences, and installation space. Online, Ars Electronica becomes a "Museum of the Future" where you can see the results in animation, digital music, interactive art, websites, and computer graphics. Webcams sited all over the museum mean you can tune in at any live moment from anywhere in the world via the center's URL. If you're bored, tune in to "the city as a harmonic symphony" at *http://web.aec.at/residence/cc.*

Art Context
http://artcontext.org

Essays, images, chat stream, and "Looking Glass Live." Another critical site where the borders of Net art are constantly challenged.

ArtNetWeb
http://artnetweb.com

Sizzling since 1994, ArtNetWeb is one of the earliest collectives to grasp the awesome potential of making and composing art on the Web. Its founders included Remo Campopiano, G. H. Hovagimyan, Robbin Murphy, and Adrianne Wortzel. Ambitious and daring, you can browse through this dizzying but nostalgic spiral of past projects, exhibitions, performances, publications, and collaborations with institutions ranging from the Lehman College Art Gallery to the ubiquitous Walker Art Center to the Guggenheim. Be sure to inspect Readings, Theoricon, Intelligent Agent (the digital sire to the magazine), and the archives of the rowdy, rambunctious Art Dirt, a weekly

RealAudio roundtable moderated for years by Hovagimyan. If you think ArtNetWeb tried to do too much, you're correct, but in the innocence of the digital paradise it was akin to the necessary meeting of Adam and Eve—which also produced too much but launched the human race, didn't it?

Artport
http://www.whitney.org/artport

Created by Christiane Paul (curator of new media art, Whitney Museum of American Art), Artport is a portal and gallery space for Net and digital arts. The site consists of four major areas: Exhibitions (both current and past, such as the Whitney Biennial Internet art projects); Artdatabase (with links to Net art projects that have been created since the genre was first established); Collection (which archives Net and digital art in the Whitney Museum's collection); and Resources (an archive with links to galleries, networks, and museums on the Web, festivals, online Net art publications, and more). An impressive and constantly evolving site. *C.W.*

Axis of Life
http://www.ljudmila.org/quantum.east/text.html

This is the "Axis of Life," sourced in the ravaged region that used to be Yugoslavia. Life means a trip to Vukovar, the Croatian "ghost city" near the Serbian border, chats with titanic spirits from the past, like Malevich and Eisenstein, and links to virtual History, Geography, Sex, and the Body. You will not be bored here.

The Center for Art and Media (ZKM) Karlsruhe, Germany
http://on1.zkm.de/zkm/e/

Plunked down in a modest, yet busy town near Frankfurt, ZKM is the world's largest institute for arts and "media," a term that straddles the two centuries it celebrates. Online, The Open Video Archive is an interactive free-for-all where you can upload and download videos from ZKM's archive of video art. Check out Exhibitions for the enormous "Net_Condition" extravaganza, the first exhibition to entertain the proposition that Net art is serious—and still the most complete. This site requires lots of proprietary software, but it more than pays for its athleticism by offering incisive links to interesting external artist sites published elsewhere on the Web. Hey, there is never a reason not to hit here.

chris.053
http://smellbytes.banff.org

Jenny Marketou's fictional bot, chris.053, is based on the infamous character Jean-Baptiste Grenouille, from Patrick Süskind's book *Perfume*. To taste, smell, and bite this fascinating story you will need a JavaScript-enabled browser.

The Art of Christo and Jeanne-Claude
http://www.christojeanneclaude.net/

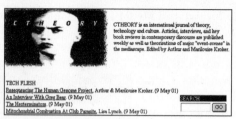

CTHEORY is an international journal of theory, technology and culture. Articles, interviews, and key book reviews in contemporary discourse are published weekly as well as theorisations of major "event-scenes" in the mediascape. Edited by Arthur and Marilouise Kroker.

TECH FLESH
Resequencing The Human Genome Project, Arthur & Marilouise Kroker. (9 May 01)
An Interview With Greg Bear. (9 May 01)
The Hexterminators. (9 May 01)
Mitochondrial Combustion At Club Parasite, Lisa Lynch. (9 May 01)

SEARCH
[] [GO]

CTHEORY
http://www.ctheory.com/

A superbly updated center affiliated with Montreal's Concordia University for articles, reviews, and metaphysical speculation on the meaning of the digital arts for virtually every aspect of society. The site categories include Tech Flesh, Reviews, and Global Algorithm. Both the subjects and the attitudes are wildly diverse, from "Transmitting Architecture: The Trans-Physical City" to "The Political Economy of Virtual Reality: Pan-Capitalism" to "The Posthuman View on Virtual Bodies." To experience multimedia art and electronic poetry, follow the Digital Dirt link.

"Defining Lines: <Breaking Down Borders"
http://cristine.org/borders

This online exhibition highlights the blurring of boundaries that defines artistic practice in the twenty-first century. From downloadable software to computer viruses to alternative browsers and gaming patches, and from

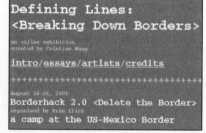

online theater to e-books and alternative network servers, what constitutes "art" is being redefined as emerging technologies and mediums are giving artists the tools to a new means of creative

expression. "Defining Lines: <Breaking Down Borders" was produced in affiliation with Borderhack 2.0, a three-day festival/camp at the United States-Mexico border designed by activists in the Net art community to "delete the border." *c.w.*

Entropy8Zuper
http://entropy8zuper.org/

Entropy8Zuper is a collaboration between Auriea Harvey (Entropy8) and Michael Samyn (Zuper). Their recent work *Eden.Garden 1.0*, which converts website code into animals and plants in a virtual world, premiered in the exhibition "010101: Art for Technological Times" at the San Francisco Museum of Modern Art (see entry for exhibition earlier in this section). *A.G.*

First Pulse Projects
http://www.geocities.com/firstpulseproj

First Pulse Projects is an art-science collaborative of uncommon intensity and dedication. The principals are Dr. Merrill Garnett, artist and photographer Bill Jones, and painter and digital artist Joy Garnett. Their strength is a network of online interactive workstations, where real-time sound, video, and 3-D animation zap back and forth. Taste this situation whenever and wherever you can.

Foundation for Digital Culture
http://www.digicult.org

The site of this not-for-profit dedicated to the promotion of Net and digital art is a portal to fifteen member organizations, including digital standards like Rhizome and the lyrical äda'web.

Franklin Furnace
http://www.franklinfurnace.org/virtual/

"On a mission from God to make the world safe for avant-garde art." The Furnace has been racing out in front of even the avant-garde for more than twenty-five years. It leaped out of its rustic gallery in downtown Manhattan and has been almost totally Web-based since 1997. Franklin Furnace gleefully spits out its message on its own site now in netcasts, artist biographies, its archival history of performance art, links, and a wondrous manifesto by founder Martha Wilson, "The Whys of Deinstitutionalization." If you click on The Future of the Present in the Now, Here you will get a thoroughly interdisciplinary real-world archive of live performances by Franklin Furnace artists-in-residence at Parsons School of Design, which brings together the modes of practical and fantastic conceptual design. You'll need both Flash and RealPlayer to watch the cavorting. (See also the listing for Martha Wilson's own website later in this section.)

Gallery 9 at Walker Art Center
http://www.walkerart.org/gallery9

Artifice meets interface here, driven by Steve Dietz, one of the pioneering curators of online art. Gallery 9 offers "artist commissions, interface experiments, exhibitions, community discussion, a study collection, hyperessays, filtered links, lectures and other guerilla raids into real space, and collaborations with other entities." Linked entities have included Franklin Furnace, the late but still influential äda'web, ArtCenter College in Pasadena, and the Austin Museum in Austin, Texas (a lively cyberart town). The artists range from Diane Ludin ("Harvesting the Net::Memory Flesh") and Stephen Vitiello ("CrossFade," a deconstruction of sound), to the mysterious masterminds behind 0100101110101101.org.

Ken Goldberg
http://www.ieor.berkeley.edu/~goldberg

Teacher, theorist, and activist, Ken Goldberg is a major digital thinker who teaches at the University of California, Berkeley. His ideas and work about robotic art and technology is a singular gem. Enjoy it in one focused dose at The Robot in the Garden.

irational.org
http://www.irational.org

Eduardo Kac
http://www.ekac.org

A central, radical presence in Web space-time thinking, Kac is one of the main developers of the "teleporting" esthetic, in which "live" elements and actions occur simultaneously in several parts and places. You will find evidence of his boundless energy and drive all over this site, in several languages and gratefully bolstered by serious theoretical texts and documentation of a rich webcast symposium on his work in 2000, "Art, Science and Free Speech: The Work of Eduardo Kac."

Dr. Lev Manovich
http://www.manovich.net

Manovich plays computer games, teases your mind, takes you on a boat ride in St. Petersburg, and offers Favorite Fashion Sites. He is also an intensely serious theorist (*The Language of New Media* published by the MIT Press). He is, in brief, the new Russia.

"Metabody: The World's First Collaborative Visions of the Beautiful" (by D.D.**)**
http://www.ps1.org/body/

Commissioned by George Waterman III in 1997, "Metabody" invites viewers to redefine the historic concept of "beauty" for themselves by uploading JPEGs or GIFs from their desktop to the constantly changing global gallery. Here we see image after image both on the runway and in the archive of wildly diverse visions of bodily beauty submitted over the years. As an interactive work

Welcome to
METABODY
The World's First Collaborative
Visions of the Beautiful

Click Here for a Radical Alternative Image

of digital art, it bespeaks of Walter Benjamin's theory of the "aura" of the original work of art and of the unstable balance between the "unique" and the "reproduced" work—both of them often sizzling—in the age of digital reproduction. *c.w.*

Moralpornography.com (by D.D.)
http://moralpornography.com

In 1978 the pioneer feminist writer, Angela Carter, called for a "moral pornographer . . . an artist who uses the logic of a world of . . . sexual license for both genders." Early in 2001, this logic first emerged on two sites (the "censored" site hailing from New York) and an exhibition in Copenhagen. Yes, it's a critique of the traditional artist viewing his model—here the women are active and in command. But they're also sensational to look at, hear, watch in streaming video, and even (subtly) collect. Thousands of moral examples of erotic beauty await you, along with critical essays and interactive eros games. By provoking the viewer to engage the body in its most intimate form, this double-faced URL argues that the price of freedom is "eternal voyeurism." *c.w.*

Netart Initiative
http://www.netart-init.org

One of first digital salons in New York, with live webcasts and archived video documentary of live events, panel discussions, and presentations (including the work of digital artists like Maciej Wisniewski, Ricardo Dominguez, Prema Murthy, Mark

Tribe, Diane Ludin, and Francesca da Rimini). Curators have included Martha Wilson, Kathy Brew, Cristine Wang, and Zhang Ga. Netart Initiative is a functioning digital salon created out of a hub of institutions working in new media: Parsons School of Design, Thing.net, Thundergulch, Franklin Furnace, Walker Art Center, Postmasters Gallery, the School of Visual Arts, and the Alternative Museum. *c.w.*

no-such
http://no-such.net/

No-such emerged out of the ashes of hell.com, a now legendary "private parallel web" housing a whole crew of fringe Net artists. No-such acts as a portal into these same artists—people like absurd.org, Andrew Forbes, Jodi.org, and dividebyzero.org. *A.G.*

Once Upon a Forest
http://www.once-upon-a-forest.com/

This is the art site of Joshua Davis, one of the world's top Flash programmers. Each month a new visual feast appears. *A.G.*

Plexus

http://www.plexus.org

Established in 1994, Plexus has provided a forum for Net artists, writers, and other purveyors of digital culture. Here art disguises itself as a primitive video game or an electronic anatomy lesson. Discussion boards, reviews, critical essays, curated and individual online projects, and a

slide registry form the crux of this domain. As of recent, Plexus intends to improve upon its cosmetics and overhaul its site in general. We fervently hope it will remain a neat showcase for art and ideas.

"Re: Duchamp"

http://cristine.org/duchamp

With over thirty international artists (including those who pioneered the development of Net art) digital art goes to the Venice Biennial. "Re: Duchamp" celebrates the process of visual sampling in a world where the line between original and copy has been blurred, and the medium is the readymade. The exhibition forms part of the Markers Project, which involves organizations in Venice including the Peggy Guggenheim Collection, the Biennale Arti Visive, and the municipality of Venice itself. *c.w.*

Refresh
http://www.artmuseum.net/Refresh/index.html

Twenty-two artists, including Alex Galloway, Jenny Holzer, and Entropy8Zuper, have created digital projects that are both works of art and functional screensavers. Download freely and dig in!

Rhizome
http://www.rhizome.org

Rhizome calls itself a non-profit "community," but it really is quite selective; high-tech hipness, wit, and brains wall out lots of dullards. It is a huge site, jammed with works of digital art focusing upon the strange, spare qualities of the Web. Recently, the opening page required you to type in "I am not" in order to enter the site—evidence of Rhizome's interactive leanings. The featured works of art are usually called "objects" that are either "cloned" here or linked to external sites. You can view the clones in Rhizome's own database but you must link to others to witness them in their natural habitat and in their "original" state. Everything tickles your brain here. Of course you can download lots of stuff to make surfing through Rhizome's jammed pixels a multisensory treat. Subscribe to the email list and receive artbeats regularly.

Stelarc
http://www.stelarc,va.com.au/

Stelarc appears to be a performance artist from Australia with a large following but he is in fact a demented scientist who relies

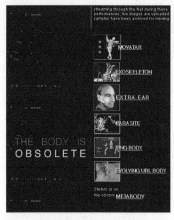

heavily on technology to explore relationships between humans and machines. "The Body is Obsolete," he declares but proceeds to lay the flesh out in striking, often morphed images. Watch out: you will see bodies with extra ears, parasitical limbs, and—in one notable case—Stelarc sprouting sculpture out of his trachea. A site for muscular brains, wits, and strong stomachs.

"Terrible Beauty" (by D.D.)
http://here.is/TERRIBLEBEAUTY

First performed and uploaded in the fall of 1997, "Terrible Beauty" is an interactive, evolving work of metamedia global theater, in which the viewer plays an active, critical role (each time the story leaps into a new phase). It uses the fronts and backs of bodies and 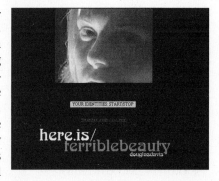 faces on the Web as theatrical partners with the real fleshbound artist/performer in front of you in galleries, museums, and theaters. In the duet between these real and virtual worlds, this seminal work of Web theatre brings up questions of the body in cyberspace, the corporeal container, and its electronic doppelganger. "Terrible Beauty" blurs the boundaries of what is real and virtual. It also intensifies both. *C.W.*

Thing.net
http://bbs.thing.net

A loose, billowing web of digital artist energy with lines to homes and studios in New York, Amsterdam, Berlin, Frankfurt, Rome, and Vienna. If you want to "hang out" with the avant-garde and join in lively chat rooms, Thing.net is your thing. You have to enroll as a member to sample all the functions and contents which include audio, video, and art reviews. Go to Threads for news (geared to new media, a bulletin board where everyone is free to vent, or Thingest (the in-house mailing list). For best performance, use a Java-enabled browser like Netscape Communicator 4 or Internet Explorer 3.01 and RealPlayer. For anyone who wants to connect with the new media avant-garde, this site is essential.

Turbulence
http://www.turbulence.org

James Turrell's *Roden Crater*
http://www.rodencrater.org

TV Gallery Moscow, Russia
http://www.tvgallery.ru

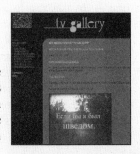

A blessedly bilingual reportage on the state of the media arts in Russia, it lists exhibitions of Russian and foreign artists at Moscow's TV Gallery. This site also offers streaming video, biographies,

project documentation, films, and video-dominated installations both in Moscow and beyond. Media theory is here, too, in the writings of artist Tatiana Gorucheva. Best of all, the center's founder, Nina Zaretskaya, senior artist Andrei Velikanov, and others have complied an interesting cross section of external links. *v. s.*

Bill Viola
http://www.artmuseum.net/viola2/fr_splash.html

This is a great place to survey Viola because ArtMuseum.net presents a comprehensive survey of his video work from 1972 to 1996 (the year when his young master status in the medium began to be widely accepted). I ought to disqualify myself from pretending to critique Viola because we have been friends and collaborators since 1972, but I doubt you'll contest my objectivity when I tell you his work is a must-see for anyone interested in video art. His deep and abiding interest in things of the spirit rather than mere reality or mere medium is everywhere abundant here. He uses streaming video to examine the mysteries of life, death, dreaming, and even the reflection of the world in the eye of a cow, one of his more infamous tapes. You'll see sixteen Viola installations here, including *The Sleepers* and *The Crossings*, along with preparatory notes and drawings.

For the past decade, these works were presented in various exhibitions at MOMA, the Whitney Museum of American Art, San Francisco Museum of Modern Art, and Musée d'Art Contemporain, Montreal. Obviously you have to download RealPlayer video to see anything here. Do it! View it!

Martha Wilson
http://www.marthawilson.com

(See also the entry for Franklin Furnace earlier in this section.)

"The World's First Collaborative Sentence" (by D.D.)
http://here.is/THESENTENCE

What is now known simply as "the Sentence" has the honorable distinction of being the first Web-based artwork acquired by a major museum (the Whitney Museum of American Art, 1995), and the first website ever to be sold (purchased by the late American collector, Eugene Schwartz, 1994). It is a constantly growing multimedia document. Aesthetic responsibility for the project's content goes to the readers, who subsequently became collaborators in a textual genetic process by adding new texts, images or sounds of their own. An interactive, "open-ended" digital work of art, this Net art "classic," poses questions about authorship, copyright and ownership regarding the "work of art in the age of digital reproduction." We strongly recommend that you try to visit the last chapter to see the most extravagant contributions. *c. w.*

%WRONG Browser
http://www.wrongbrowser.com

This new website from Jodi.org offers four browser applications for download. Install any of the browsers and you will get a taste of the dirtier side of network data. Internet Explorer it is not. *A. G.*

Young-hae Chang Heavy Industries
http://www.yhchang.com/

These Flash movies aren't interactive, yet the hard-hitting language and simple aesthetic make for a compelling experience. Artist Young-hae Chang combines plain text with soundtracks, often showing how political situations touch individual lives. *A. G.*

ARTISTS

Among the artists who would certainly be obsessed by the Web at this moment are Michelangelo, da Vinci, Manet, Picasso, Duchamp, Stieglitz, Pollock, Warhol, and Rauschenberg (who, since he is only seventy-six, may yet convert). In fact, all of these activist innovators can be found with your browser at this moment, primarily because they triumphed in traditional media. But that doesn't mean they aren't triumphing now. Nor does it mean that those artists who present their work on the Web won't be continuously probing for new ways to show, touch, or hear what they made. In many of the sites below (which are focused entirely on artists that produced pre-Web, pre-new media bodies of work) you'll find it almost impossible to see any single painting or object without some form of recourse to its context or its creator (interviews, childhood photos, links to related works, etc.). In part, this is why we have chosen these sites. But the rapid pace of invention in this medium means you should shop on your own. Any day now some critic or collector will upload a site focusing on the teenage snapshots of Man Ray, the early charcoal drawings of Willem de Kooning, the late eroticism of Picasso . . . or your own wild specialty. Furthermore, every museum or gallery that brings the artist into the "real" world in an exhibition will surely post his or her work on its URL, thus adding to the long, long list of artist sites you will find even now on search engines like Google. The question is not whether art can find a place on the Web but whether the Web can survive the impact of art. But if it can't, if the Web must collapse under the weight of billions and billions of pieces of art, this won't be so bad. It would be akin to dying at a ripe old age in the midst of making love.

ARTIST DIRECTORIES

the-artists.org
http://the-artists.org

Major twentieth-century and contemporary visual artists.

AskART
http://www.askart.com

Comprehensive database for twenty-five thousand American artists, including auction records, biographies, and images.

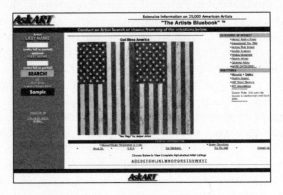

Catharton Communities: Artist Index
http://www.catharton.com/artists/

Portal to online exhibitions, articles, and official and unofficial websites.

(See also the sections on ART HISTORY AND CRITICISM and ART RESOURCES for related listings.)

INDIVIDUAL ARTISTS

VITO ACCONCI
Acconci Studio
http://www.acconci.com/

FRANCIS BACON
Francis Bacon Image Gallery
http://www.francis-bacon.cx/

AUBREY BEARDSLEY
Aubrey Beardsley Art Image Collections
http://www.artpassions.net/beardsley/beardsley.html

WILLIAM BLAKE
William Blake Online
http://www.tate.org.uk/britain/exhibitions/blakeinteractive

Though a part of the Tate Britain site, William Blake Online is such a powerful and unique presence that it must be considered on its own. As is customary with the Tate website, it pumps everything at us in imaginative doses—Blake's paintings, poems (which you can read and hear recited in a rich British accent), and drawings. A pure romantic, Blake believed that anything was possible, which is why his renditions of the visionary creatures haunting his dreams are more real than real; click on Meet Blake's

Cast of Characters to sense his passion. Convinced that fleas were inhabited by the souls of "bloodthirsty" men, Blake gives us the soul of the Ghost of the Flea in unforgettable human form, his tongue darting out from his mouth in search of . . . you, perhaps.

Other Blake sites:

Tyger of Wrath: William Blake in the National Gallery of Victoria
http://www.ngv.vic.gov.au/blake/

The William Blake Archive
http://www.blakearchive.org/

CHRIS BURDEN
RealAudio interview at the Royal Academy of Fine Arts, Stockholm
http://www.artnode.se/burden/

ALEXANDER CALDER
Calder Foundation
http://www.calder.org/

MARY CASSATT
"Mary Cassatt: Modern Woman"
http://www.boston.com/mfa/cassatt

DALE CHIHULY
http://www.chihuly.com

SALVADOR DALI
Gala-Salvador Dali Foundation
http://www.dali-estate.org

The Salvador Dali Museum
http://www.salvadordalimuseum.org/

MARCEL DUCHAMP
Marcel Duchamp World Community
http://www.marcelduchamp.net

M. C. ESCHER
M. C. Escher: Life and Work
http://www.nga.gov/collection/gallery/ggescher/ggescher-main1.html

The Official M. C. Escher Website
http://www.mcescher.com

World of Escher
http://www.WorldOfEscher.com/

VINCENT VAN GOGH
Van Gogh Museum
http://www.vangoghmuseum.nl/
bis/top-1-2.html

Van Gogh's van Goghs
http://www.artmuseum.net/
vangogh/gateway.asp

The Vincent van Gogh
Gallery
http://www.vangoghgallery.com/

FRIDA KAHLO
Frida Kahlo & Contemporary Thoughts
http://www.fridakahlo.it/

ALEX KATZ
http://www.AlexKatz.com/

ANSELM KIEFER
Anselm Kiefer: Works on Paper in the Metropolitan Museum of Art
http://www.metmuseum.org/explore/KIEFER/el_kiefer_splsh.htm

MARK KOSTABI
http://www.markkostabi.com/

EDOUARD MANET
Manet's Studio
http://www.mystudios.com/manet/manet.html

TOM MARIONI
Golden Rectangle
http://www.silentgallery.com/marioni

Eons ago, Tom Marioni created the first "Museum of Conceptual Art" in San Francisco, a conceptual action for which he is justly celebrated. Now he is foxing us with *Golden Rectangle* in the heart of the Silent Gallery. Watch out. This may be louder and madder than you think. Bring JavaScript and Flash 4 along.

JOAN MIRO
The Joan Miro Foundation
http://www.bcn.fjmiro.es/

Intriguing, valuable, and infuriating. At this site you can view plenty of Miros that you would probably not see outside of Barcelona, including public murals executed in his later years in choice sites like the airport. The foundation

is jammed with many of Miro's stirring "Wild Paintings" made around the time of the tempestuous Spanish Civil War. Many neatly arranged images are available here, though often in tiny scale. And then there is the usual difficulty of finding your way back to a clear starting point. Flash and QuickTime enable you to virtually explore the galleries, though in small, disappointing scale.

MODIGLIANI
Modigliani: The Legend Lives On
http://mystudios.com/gallery/modigliani

CLAUDE MONET
Welcome to Claude Monet's
http://intermonet.com/

ALICE NEEL
http://www.AliceNeel.com/

ISAMU NOGUCHI
Isamu Noguchi Garden Museum
http://www.noguchi.org/

GEORGIA O'KEEFFE
The Canyon Suite at the Kemper Museum of Contemporary Art
http://www.kemperart.org/okeefe1.html

Georgia O'Keeffe Museum
http://www.okeeffemuseum.org/

PABLO PICASSO
The Early Years: 1892–1906
http://www.boston.com/mfa/picasso/

On-Line Picasso Project
http://www.tamu.edu/mocl/picasso/

Universo Online of Brazil
http://www.uol.com.br/23bienal/especial/iepi.htm

JACKSON POLLOCK

The breakthrough American artist of the 1940s and 1950s, Pollock, despite the controversies surrounding his mercurial life and style, is now a legend soaring far beyond reality, or even the power of his paintings. The method he devised—flinging and spattering paint rather than carefully brushing it down—outraged traditionalists in his day. "I am nature," he once said when attacked for never representing nature. Both MOMA and the National Gallery of Art offer brilliant visual surveys of his work, if reserved in critical judgment. The Pollock-Krasner House and Study Center displays the house and the work of Lee Krasner, the woman with whom Pollock lived till near the violent end of his life. And of course the website for the infamous film, *Pollock*, starring and directed by Ed Harris is worth inspection (though it oddly lacks any streaming video clips). The film succeeded only on a primitive, chaotic level—occasionally quoting Jackson directly about his work and occasionally giving

evidence of his sophisticated intelligence. Of course it preferred to portray him as an out-of-control man. But it does intensify the myth that is now much more than the man or even his extraordinary work.

Pollock presented by Sony Pictures Classics
http://www.spe.sony.com/classics/pollock/

Pollock online exhibition at MOMA
http://www.moma.org/exhibitions/pollock/

Pollock exhibition at the National Gallery of Art
http://www.nga.gov/feature/pollock

Pollock-Krasner House and Study Center
http://www.pkhouse.org

MAN RAY
http://manray-photo.com

REMBRANDT
Rembrandt Myself . . .
http://www.mystudios.com/rembrandt/rembrandt-myself-opening.html

Rembrandt Pavilion
http://parallel.park.org/Netherlands/pavilions/culture/rembrandt/

DIEGO RIVERA
Diego Rivera Web Museum
http://www.diegorivera.com

(See also Detroit Institute of Arts entry in MUSEUMS section.)

DANTE GABRIEL ROSETTI
The Rosetti Archive
http://jefferson.village.virginia.
edu:2020/

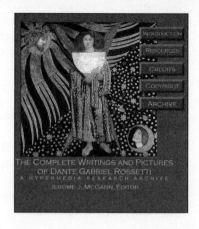

MARK ROTHKO
National Gallery of Art
http://www.nga.gov/feature/
rothko/

JOHN SINGER SARGENT
(See Fogg Museum entry in
Museums section.)

BEN SHAHN
(See Fogg Museum entry in Museums section.)

LOUIS COMFORT TIFFANY
Louis Comfort Tiffany at the Metropolitan Museum of Art
http://www.metmuseum.org/explore/Tiffany/RELEASE.HTM

JOHANNES VERMEER
About Johannes Vermeer Art
http://www.about-vermeer-art.com

Johannes Vermeer: The Art of Painting
http://www.nga.gov/exhibitions/vermeerinfo.htm

LEONARDO DA VINCI
The Drawings of Leonardo da Vinci
http://banzai.msi.umn.edu/leonardo

At last a homepage that is visually stunning yet simple in its approach. Leonardo himself speaks immediately here, attacking dim-witted critics, "folks little indebted to Nature, since it is

only by chance that they wear the human form and without it I might classify them with the herd of beasts." Here you'll find thirty-nine thumbnail images of his dated drawings. Click—and bang! You're there, inside the drawing, with another link that allows you to take charge of more information about each work. More links take you to museums and websites offering history and interpretation, some aimed directly at kids.

Other da Vinci sites:

Leonardo da Vinci: Scientist, Inventor, Artist
http://www.mos.org/leonardo/

The Leonardo Museum
http://www.leonet.it/comuni/vinci/

National Museum of Science and Technology
http://www.museoscienza.org/english/leonardo/

ANDY WARHOL
The Andy Warhol Museum
http://www.warhol.org/

One Stop Warhol Shop
http://osws.artmuseum.net

ADRIANNE WORTZEL
Wortzel's homepage at ArtNetWeb
http://artnetweb.com/wortzel/

ART HISTORY
AND CRITICISM

The Web is not only eager to show you visual art; it is hugely eager to talk about art with the same volubility it lavishes on most other subjects. In the beginning no one believed that the Internet would revel in chats, dialogues, writing of all kinds, and, particularly, scholarship and criticism. If you study its institutional origins in the desire to exchange scientific and military documents—or even in its later evolution into the World Wide Web—you do not detect the slightest awareness that you and I would turn this method of instant written/visual communication into a humanistic enterprise. But that is what the Web has become, in part.

Below we have tried to give you a sense of where you can find extraordinary critical and historical overviews of genres ranging from abstract expressionism to the arts of India to the recondite past of daguerrian photographs to the Fluxus Portal. Critics, like Arthur Danto and Camille Paglia, are loud and clear as well, in some cases using this medium as the first step in publication. In addition, here and there you will be invited to post questions or declare your own impassioned beliefs. Finally, it is altogether fitting that the sponsors of these critical sites range from august universities and periodicals to obsessed individuals eager to show the world everything they know. The world mind is asymmetrical, thanks to its democratizing technological base.

GENERAL ART HISTORY SITES

Art History Resources on the Web
http://witcombe.sbc.edu/ARTHLinks.html

The Artchive
http://www.artchive.com/

Loggia
http://www.loggia.com

MyStudios
http://mystudios.com

The PartheNet
http://home.mtholyoke.edu/~klconner/parthenet.html

WebMuseum
http://metalab.unc.edu/wm

SPECIALIZED SITES

Abstract-art.com
http://abstract-art.com/index.shtml

A magical and sometimes monstrous mystery tour of the non-figurative edge of artmaking by one of its practitioners, Ron Davis, whose clean, flat paintings are found in major museum collections across the world—and whose brand new "digital abstraction" centers the homepage. Here he summons every single image or reference he can to legitimize his passion. You'll find nearly six hundred webpages and thousands of images of abstract art, both expressionist and minimal, historical and contemporary, by the famous and the unknown, in every possible

media. Go most of all to Grandfather Gallery, where you'll find Pollock, Paolo Ucello, Piet Mondrian, Robert Delaunay, and others. There is a splendid homage to the late Robert Motherwell, jammed with great paintings. And it's interactive! Davis welcomes you to send him JPEGs to post on his site to share with a great worldwide community of abstract expressionists and illusionists.

Abstract Expressionism
http://artnetweb.com/abstraction/abexpress.html

This site is introduced with a brilliant one paragraph summary of this dramatic, misunderstood movement that rightly connects it to the European modernist influx in the wake of World War II. A lovely 1957 painting by de Kooning anchors the homepage. As a generic quickie, this site is among the best. The sections are simple, upbeat, and broad ranging: Total Risk, Freedom, Daring; The Pioneers; Between the Wars; and The Museum of Non-Objective Painting. There are also special references to abstract expressionism's impact on photography, theater, architecture, and poetry. If this site also provided moving video and film dimensions to its coverage, I would call it near 9.5. Well, improvement is in their cards.

Aesthetics Web Sites
http://www.aesthetics-online.org/net/ae-web.html

Here you will wind a smooth, competent listing of nearly all the journals that take up esthetic theory in a century when new theories pop up on a monthly basis, making even the dizzying 1980s, when each year brought us a new "post"—modern, minimal,

and even post-modern. Go first to The Journal of Aesthetics and Art Criticism, published by the American Society for Aesthetics. It's usually efficiently hip in the best academic mannerism.

ArtLex
http://www.artlex.com

If P. T. Barnum had earned an MFA and went on to teach high school art, he would have probably blitzed the world with ArtLex, a huge, relaxed, good-humored site filled with the standard line on just about every certified artist or movement it touches. For sheer bulk—thousands of entries—ArtLex is a must-see. If you want a quick update on Adolph Gottlieb, Mark Tobey, or Adja Yunkers, click on the Abstract Expressionism shortcut. Or to browse terms and artists alphabetically, pick a letter to fly right there where you will find clean, clear (but oft uninspired) descriptions. For larger versions of the thumbnail images, click on the title of the artwork. However, if you are in search of the avant-garde, new media art, or piercing critiques, don't go past the homepage.

ArtMagick
http://www.artmagick.com

If the decadent art of late nineteenth-century Britain (summed up in movements like Pre-Raphaelitism, symbolism, and art nouveau) has a vanguard memoir, this is it. This "non-profit virtual art gallery," to which you can contribute via the Amazon Honor System, is filled with lush portraits, landscapes, and nudes, all pushing various borders of color, tone, and sexual desire (the latter being often unrequited—the only dependable affair, a wise man once concluded). Changing constantly, the site recently dangled before us a bare androgynous creature standing before a shut door in a choice painting entitled *Love Locked Out* by Anna Lea Merritt, an obscure American artist. It

sums up the wistful appeal of this rare site, which, among its features, offers images by well-known artists like Sir Edward Burne-Jones (seventy images) and an MP3 archive filled with beautiful and sad music from a bygone era.

Artmargins: Contemporary Central and Eastern European Visual Culture
http://www.artmargins.com

Both a linked and a content site with fresh news and discoveries about an entire European sector on the move after decades of official repression or indifference. You can learn about institutions like Metelkova in Llubjana, Slovenia (once the barracks for the former Yugoslavian army, now "occupied" by artists, writers, and performers determined to use it as a cen-

ter for the vanguard arts). You can hear and link here to similar institutions in Hungary, Croatia, Romania, and beyond.

The Arts in Victorian Britain
http://65.107.211.206/art/artov.html

This is a tasty subsection of the Victorian Web, a huge, heavy, and exhaustively researched website devoted to Victorian England. Brown University Professor George P. Landow exceeds himself here with a bracing barrage of visual darts mixed with plenty of text, some of it drawn from Victorian magazines and art criticism. The parade of Victorian sculpture—some of it offering images of works now lost or impossible to find—is revelatory.

If you think the Victorians were prudish, wink your eye at the parade of nude male and female sculptures in Sculpture Overview. Otherwise, this is a site that makes your average Ph.D. thesis seem like an advanced comic book.

Arts of India
http://www.kamat.com/kalranga/art

A diverse assortment of art awaits you here at this beautifully illustrated website. From unusual leather puppets to prehistoric cave paintings, to dance and sculpture, this site is cavernous. Newcomers to the Indian arts will benefit from a visit to the Timeline of Indian Art. Important essays and images of the erotic arts should not be missed. *v. c.*

Asianart.com
http://www.asianart.com

Svelte online journal that opens into a forum for scholars, museums, commercial galleries, and layperson zealots. You can not only sample thirty online art exhibitions but you can also participate in two message boards. The first board is lively and general, offering you the opportunity to sell your antique Tibetan rug and to post questions, both trivial and esoteric. The second message board, launched in mid-2001, goes after Chinese and Japanese art inscriptions and is moderated by an expert who will help you date and identify whatever you own on the basis of uploaded images and descriptions. The Association page is a gateway to groups like the Patan Museum, which focuses on Tibetan and Nepalese culture. Sure you can shop here and glean the expected histories of Asia, but you'll also find powerful exhibitions like "The Wait of Orphans," which graphically unveils the horrors of Pol Pot's infernal war against his own citizens, or articles like "Ghosts, Demons and Spirits in Japanese Lore," an eloquent treatment of the mystery of death

in past and current Japanese culture. A big site with endless surprises.

The Baobab Project
http://web-dubois.fas.harvard.edu/dubois/baobab

The Baobab Project is a necessity for scholars and students interested in African visual culture. Established in 1994, this Harvard University Department of Fine Art's project has grown into a multifaceted research tool with audio- and video-spiked hypertexts, a 17,000-image database, an index of African cultures, and more. Presentations include Yoruba masking traditions, Islamic culture, and textile design. *v. c.*

The Daguerreian Society
http://www.daguerre.org

Invented in 1939 by Louis-Jacques-Mandé Daguerre, this prephotographic process is unique in that it utilizes a light sensitive silver-coated plate rather than a negative. The Daguerreian Society, founded in 1988, is the world's fastest growing photographic society with over nine hundred individual and institutional members. Through their well-organized website, the society provides an ample gallery of historical and contemporary daguerreotypes (from ghostly portraits to beautifully shad-

ed panoramas). The Resources page is packed with nineteenth and twentieth-century texts, as well as a brief illustrated history of the daguerreian process, links, and news and events. Enthusiasts should commit this URL to memory. *v. c.*

Arthur Danto

Esteemed art critic and Colombia University philosophy professor, Arthur Danto has written brilliantly and bitingly about all forms of contemporary art. He is art critic for *The Nation* and has authored numerous books, including *Embodied Meanings: Critical Essays and Aesthetic Meditations*. Search *The Nation* website (*http://www.thenation.com*) for the following art articles by Danto: " 'Sensation' in Brooklyn," "Degas in Vegas," and "Life in Fluxus." Danto's excellent article "Outsider Art" does not surface using the magazine's search engine, but
you can retrieve it here:
http://past.thenation.com/issue/970310/0310dant.htm.

Other Danto links on the Web:

Danto's bio through Columbia University
http://www.columbia.edu/cu/philosophy/deptinfo/text/danto.html

Short article on Danto's "end of art" thesis
http://www.rowan.edu/philosop/clowney/Aesthetics/philos_artists_onart/danto.htm

Philosophy Now article
http://www.philosophynow.demon.co.uk/danto.htm

Davidson Art Center Print Collection
http://www.wesleyan.edu/dac/coll/prints.html

The Davidson Art Center is part of Wesleyan University. This center's print collection is one of the foremost print collections

in America.

Fluxus Portal
http://www.fluxus.org

In the 1960s the Fluxus movement changed the way people looked at art: found poems, mail art, happenings, silent orchestras, collages, etc. The celebration of change and intermedia makes this post-Dada phenomena a hard to define social and artistic experiment. Still confused? Subscribe to the FLUXLIST for definitions, history, resources and plenty of lively discussion. The Fluxus Portal is chockfull of goodness for newcomers and experts alike. Book and video recommendations, links to related movements, and all your favorite Fluxists (Al Hansen, Yoko Ono, and Al Hendricks to name a few). *v. c.*

The Futurism Website
http://www.futurism.fsnet.co.uk/

Movement, power, force, motion, speed: these were the primary influences on the movement that swept through the European art scene in the early 1900s. A facsimile of Fortunato Depero's masterful *Bolted Book* and audio clips await you here as well as essays, a rare photo album of the Italian futurists, a thirty-six year timeline, and the futurist database which contains more than 145 biographies. *v. c.*

Himalayan Art
http://www.himalayanart.org

This site hosts a plethora of paintings, sculpture, prints, and murals that surpass all Himalayan art currently on exhibit in Western museums. The tinkle of bells and an attractive design usher visitors into five sections: Purpose (the aims of the Himalayan Art Project), Collections (exquisite finds compiled

from reputed museums and private collections), Exhibits (including historical and contemporary photographs of the region in addition to art), Books (for purchase directly from the site), and Links. Each annotated work, from the intricate designs of Tibetan book covers to the terrifying (and sometimes grotesque) paintings of deities and monsters, can be explored in detail with the impressive zoom feature. Other niceties: printer-friendly art and a speaking glossary. May Mahakala, the protector, watch over you. *v. c.*

National Graphic Design Archive
http://ngda.cooper.edu

It's all here: propaganda posters, Dadaist magazines, and even a vintage AC/DC album cover. Take a peek at this massive searchable database of twentieth-century graphic design housed in the collection of the Cooper Union School of Art and you will be rewarded with a hearty dose of works on paper. While only registered educators can gain full access to the archive, the casual visitor may peruse a substantial amount of images accompanied by contextual text. *v. c.*

Camille Paglia
A sizzling, saucy feminist culture critic who has reinterpreted virtually all of art history from the view of one (supposedly) neglected gender. Paglia is Professor of Humanities at the University of the Arts in Philadelphia and the author of three best-sellers, including the provocative *Sexual Personae: Art and Decadence from Nefertiti to Emily Dickinson*. You will find her books reviewed and her apothegms quoted all over the Web. For a quick taste, if not bite, go to:

Camille Paglia column archives at Salon.com
http://salon.com/archives/2000/col_pagl.html
The Camille Paglia Checklist

http://kbs.cs.tu-berlin.de/~jutta/cpc/index.html

Bits and Pieces of Camille Paglia's *Sexual Personae*
http://www.theabsolute.net/misogyny/paglia.html

Camille Paglia—Feminist Fatale
http://privat.ub.uib.no/bubsy/pagliaom.htm

PBS—Arts
http://www.pbs.org/neighborhoods/arts/

Save the nature films for later. PBS's will keep you enlisted for hours, if not days, with Architecture, Drama & Dance, Film, Fine Art, Literature, Music, and Pop & Folk Art. Enriched with lesson plans, multimedia, and interactive activities, you'll delight in everything from Sister Wendy's guide to relatively tame American art to the provocative "Culture Shock," which attempts to answer the question "When does art go to far?" *v. c.*

Prehistoric Art (from the Open Directory Project)
http://dmoz.org/Arts/Art_History/Movements/Prehistoric_Art/

There were too many intriguing URLs dedicated to prehistoric art to select just one or two, but the Open Directory has effectively cataloged a fair number of them. Divided into three sections—Neolithic, Paleolithic, and Petroglyphs—each link

includes a succinct description to guide you in your travels. The Paleolithic-focused websites are particularly strong with all the famous caves covered, including Lascaux and the Altamira caves. *V. C.*

The Pre-Raphaelite Critic
http://www.engl.duq.edu/servus/PR_Critic

Imagine downloading extravagant Pre-Raphaelite poetry as audio files. This site was awarded a National Endowment for the Humanities Challenge Grant in 1997 through Duquesne University. Jessie Helms, how did you let this get by?

Thais: 1200 Years of Italian Sculpture
http://www.thais.it/scultura/default_uk.htm

From Romanesque to contemporary, this image database offers a comprehensive look at the evolution of Italian sculpture. Explanatory text is minimal but the quantity and quality of the art makes up for the lack of context. Tucked in Modern Sculpture you'll find futurist Umberto Boccioni's bronze works. Use the zoom feature to examine the amazing lines of this model of power and movement. *V. C.*

ART RESOURCES

The Web is an infinite warehouse of potentially practical information. It is the infinitude that drives me to call it "potentially" practical. At the current state of the art, no browser or intelligent agent can begin to provide you with the truly human nuances demanded by your cortex before it feels in control and ready to act. More than sixty years ago Jorge Luis Borges, the demigod humanist of the last century, saw all this coming. He once wrote a story about a small nation so obsessed with preserving information that the living citizens were squeezed, with no room left for anything but paper. In *The Total Library* (1939), he traced in effect the Web's manic origins back to the ancient Greeks, who once proposed getting "everything" together in a single spot. But once this "vast, contradictory" library got built, Borges warned, "it would confuse everything, like a delirious God." You and I must stand firm against this threat. We must organize, conceptualize, fragment, and focus on every minute of every day . . . or perish. That is why this book, and particularly this section, is a strike for humanity, for the control of information, rather like democracy attempted to resist tyrants. Below you will discover more than enough sources of information and guidance to achieve almost anything you need as artist, curator, writer, editor, teacher, layperson, or just plain culture fan. If you want to sell or buy art of any kind, go instead to ART AND COMMERCE. You'll find nothing below but sweet organization. The future, as Paul Saffo once said, belongs not to content only but to context. Here God is not delirious. Here he/she is the only intelligent agent truly on your side. (Surprisingly some critical art resources, including one of our premier journals, *Art in America*, are not yet online. Fear not! Prediction: by the end of 2002, virtually all will be accessible via the Web.)

RESOURCE GUIDES
(including news, calls for artists, exhibition info, products, and services)

ArtandCulture.com
http://www.artandculture.com

ArtBase: Global Art News Service
http://www.artplanetinternational.com

ArtStar
http://www.artstar.com/

Internet ArtResources
http://www.artresources.com

Internet for the Fine Arts
http://www.fine-art.com/

NextMonet.com
http://www.nextmonet.com

World Wide Arts Resources
http://www.wwar.com

ART SCHOOL DIRECTORIES AND ORGANIZATIONS

ArtSchools.com
http://www.artschools.com

"The Art School Program Directory."

Association of Independent Colleges of Art and Design
http://www.aicad.org/

ART SCHOOLS

California Institute of the Arts Valencia, California
http://www.calarts.edu/

The Cooper Union School of Art New York, New York
http://www.cooper.edu/art/

Corcoran School of Art and Design Washington, D.C.
http://corcoran.org

Kansas City Art Institute Kansas City, Missouri
http://www.kcai.edu/

Minneapolis College of Art and Design
Minneapolis, Minnesota
http://www.mcad.edu/

Otis College of Art and Design Los Angeles, California
http://www.otisart.edu/

Parsons School of Art and Design New York, New York
http://www.parsons.edu

Pennsylvania Academy of the Fine Arts
Philadelphia, Pennsylvania
http://www.pafa.org/

Pratt Institute Brooklyn, New York
http://www.pratt.edu

Ringling School of Art and Design Sarasota, Florida
http://www.rsad.edu/

Rhode Island School of Design Providence, Rhode Island
http://www.risd.edu/

San Francisco Art Institute San Francisco, California
http://www.sanfranciscoart.edu/

School of the Art Institute of Chicago Chicago, Illinois
http://www.artic.edu/saic

School of the Museum of Fine Arts Boston, Massachusetts
http://www.smfa.edu

School of Visual Arts New York, New York
http://www.schoolofvisualarts.edu

Tyler School of Art of Temple University
Elkins Park, Pennsylvania
http://www.temple.edu/tyler

University of Texas College of Fine Arts Austin, Texas
http://www.utexas.edu/cofa/

Yale School of Art New Haven, Connecticut
http://www.yale.edu/art/

IMAGE DATABASES AND LIBRARIES

Art Images for College Teaching
http://www.mcad.edu/AICT/

Maintained by Minneapolis College of Art and Design, this "royalty-free image exchange resource for the educational community" provides loads of images in the areas of: Ancient, Medieval Era, Renaissance and Baroque, 18th–20th Century, and Non-Western. Dupe slides can be ordered for noncommercial use or you can download high-resolution images directly from the site.

Art Resource
http://www.artres.com

The unbeatable Scala Picture Library (see entry below) has partnered with Art Resource, America's largest fine arts photographic archive, to provide us with an online painting, sculpture, and architecture archive from the world's best museums. Art Resource is also the exclusive representative for the photo archives of the artists Frank Stella and Robert Indiana, as well as for the estates of Andy Warhol, Alexander Calder, and René Magritte. The website is fully searchable and currently contains over one hundred thousand fine art images. Online users can search, gather, and review image selections, download digital files, and make purchases.

ArtServe
http://rubens.anu.edu.au/

Over 150,000 art and architecture images, mainly from the

Mediterranean Basin, offered by the Australian National University.

Scala Picture Library
http://scala.firenze.it/in.dir/

Easily the most awesome image bank in the world. You can, in one way or another, get to more than one hundred thousand fine art reproductions here from sources like the Louvre, the Uffizi Gallery, the Hermitage, and the Prado. Scala enables you to reproduce these images for a licensing fee. It also publishes books, produces CD-ROMs (with DVDs to inevitably follow), and empowered the birth of the guide in your hands. If you check into the immense catalog each month you will watch it steadily grow as more images, from ancient frescos to the most daring contemporary art, are added. Search Scala by convenient keywords ("fruit," "portrait," "nude," "child," etc.), by medium, by artist, by title—even by location of the artwork in museum or city. Enlarge those thumbnails and drown yourself in beauty. If you simply can't stand not owning the ability to reproduce what you see, simply drop it into your shopping cart. Scala thought of laying all this out on the Web before anyone else and deserves bragging as well as reproduction rights.

Web Gallery of Art
http://gallery.euroweb.hu/

"The Web Gallery of Art is a virtual museum and searchable database of European painting and sculpture of the Gothic, Renaissance and Baroque periods (1150–1800), currently containing over 8,500 reproductions."

(Also see MUSEUM entries for collection databases.)

MAGAZINES AND E-ZINES

artFORUM
http://www.artforum.org

This magazine focuses on the visual arts, architecture, music, literature, and new media on an international scale.

ARTnews
http://www.artnews.com

America's oldest art magazine goes behind the scenes in the international world of art. Both the magazine and the companion newsletter are valuable sources for information on collecting, emerging artists, trends, interviews, exhibition previews, and more.

Art Press
http://www.artpress.com/

Bomb
http://bombsite.com

Recently celebrating its twentieth anniversary, *Bomb* presents interviews with artists, musicians, writers, actors, and directors.

fineArt forum
http://www.fineartforum.org/

fineArt Forum is the longest running arts e-zine. Published online each month, it focuses on articles and exhibitions pertaining to digital art but also covers all fine and performing arts, including that of indigenous world cultures. A complete archive of back issues, from 1987 to present, is available. Also check out the extensive international art resources list. *c. w.*

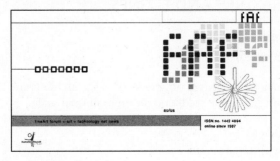

frieze
http://www.frieze.com

Companion site to the international cross-cultural contemporary art magazine. In addition to features, the site has Web projects, discussions, and news.

NY Arts Magazine
http://www.nyartsmagazine.com

Interactive online journal of contemporary art, which allows readers to post their ideas and stories to the site, with press releases, a critics corner, daily art openings listings, gallery

information, world art news, feature articles, and reviews of contemporary art. Artists can also link their websites to the magazine, making the concept of independent publishing a reality. *C. W.*

Raw Vision
http://www.rawvision.com

Vibrant quarterly magazine dedicated to Art Brut and Outsider Art.

ORGANIZATIONS AND FOUNDATIONS

American Institute of Graphic Arts
http://www.aiga.org/

Americans for the Arts
http://www.artsusa.org/

ArtJob Online
http://www.artjob.org/

ARTSEDGE: The National Arts and Education Network
http://www.artsedge.kennedy-center.org/

Arts Education Partnership
http://www.aep-arts.org/

College Art Association
http://www.collegeart.org

Graphic Artists Guild
http://www.gag.org/

National Art Education Foundation
http://www.naea-reston.org/

National Arts and Disability Center
http://nadc.ucla.edu/

National Assembly of State Arts Agencies
http://www.nasaa-arts.org/

National Endowment for the Arts
http://arts.endow.gov/

National Foundation for Advancement in the Arts
http://www.nfaa.org/

Open Studio
http://www.openstudio.org/

SEARCH ENGINES

ADAM, the Art, Design, Architecture & Media Information Gateway
http://adam.ac.uk/

"Searchable catalogue of 2,546 Internet resources that have been carefully selected and catalogued by professional librarians."

Artcyclopedia
http://www.artcyclopedia.com/

The folks at Artcyclopedia have compiled links to sites that provide museum-quality artwork. So far they have "indexed 700 leading arts sites" and offer links "to an estimated 80,000 works by 7,000 different artists."

EuroGallery
http://www.eurogallery.org

Searches the websites of six major European museums: Louvre, State Hermitage, London's National Gallery, van Gogh Museum, Vienna's Kunsthistorisches Museum, and The Hague's Mauritshuis.

ART AND COMMERCE

Quantum physics tells us that the shape and evolution of the universe is essentially unpredictable. It is as impossible to forecast as the movement of the elements of atomic structures (one of the reasons why John Cage and Fluxus may be more realistic than realist painting). The least foreseen effect of the Web on the arts was its potential of "connecting" the creator directly to his market—in effect turning the lone creator into his own agent, publisher, or dealer, rather than the starving glamour puss he/she has been portrayed as in countless movies, plays, and novels.

As the signs of this historic bombshell have detonated in the past few years—best-selling authors "publishing" their own works in cyberspace, independent filmmakers unveiling short epics online rather than in the theaters, and musicians posting their sounds for all to hear and download—you know who's screaming like stuck pigs: the fat-walleted middlemen of late capitalism (publishers, film production houses, and music companies). The art galleries and non-profit spaces haven't begun to whine and whimper yet, but I predict that soon they will . . . at least for a short time, until they join the game. By late 2002 or early 2003, we will see hundreds, if not thousands, join the ranks of aggressive creators—such as Mark Kostabi, Andrew Sullivan, Tom Clancey, Dennis Oppenheim, Barney Rossett, and this writer-artist—eager to contact viewers, readers, and minds who are also buyers.

Kostabi's story is one of the most intriguing, if only because he has spoken boldly and consistently about it. While the rest of the art world was still confined to gallery walls, Kostabi

began to auction his works online using eBay as his main venue. He began selling five-dollar postcards (he still does) and soon moved to paintings ranging in price from hundreds to tens of thousands of dollars. Of course Kostabi has always been the priest of anti-art vulgarity, twitting sacred cultural cows like "originality" and "hands-on" brushwork (he rarely lifts one, leaving the fun work to his assistants). But there is nothing about his method that others cannot learn from, including his cadre of skilled, brilliant Web-based salespersons, who field every offer and wet-nurse every buyer, thus building a healthy network of satisfied customers far beyond the stretch of your average art dealer (see *http://www.markkostabi.com*). His ideas can be found in "Ask Mark Kostabi," a regular feature in the pages of Artnet.com (*http://www.artnet.com*).

But many artists, particularly those pushing certain vanguard extremes—as Kostabi, a realist painter verging here and there on abstract flourishes, does not—need sponsors and patrons more than difficult "first sales." One superb model here is a writer named Andrew Sullivan, once the editor of the *New Republic*, now a regular contributor to *New York Times Magazine*. He has enrolled, along with other colleagues in varying media, including your author, in the Amazon Honor System. Visit *http://www.andrewsullivan.com* to read Sullivan's elegant plea for funds that will allow him, his writing, and his URL "to boldly go where no website has gone before." Up barely a year, by mid-2001 the site had attracted seven thousand dollars in funds, the contributions rolling in for ostensibly idealistic reasons simply to allow talent to flourish beyond the marketplace.

Because the Web permits a close but physically distant "link" between patron or collector and artist or writer, it allows for more independence than Michelangelo received from a hovering Pope as he dared to defame the Sistine Chapel with bold male nudes while worrying every minute about his ultimate fate at the hands of the fifteenth-century prototype of North Carolina's Senator Jessie Helms. Will the Web allow a

form of First Amendment freedom of expression to flower while continuing to pay the bills? Can the vanguard truly ignore the conservatism of a direct, if hugely sophisticated, market? When these questions are finally answered we will learn at last whether experiment and innovation require deprivation to survive or if the myth that links starvation with the avant-garde is truly the myth it appears to be.

My critical contrarian point: beyond the Amazon Honor System, we must also honor auction houses like Sothebys, which has been reaching out to activate the "direct" buyer and collector for years, and publishers like Barnes and Noble (primed to offer us electronic variants of the traditional book which might be downloaded on Palm Pilots). Certainly they and other entrepreneurial wits at Amazon.com, eBay, and beyond are moving at least as rapidly as Kostabi, Sullivan, and company.

That is why our art commerce listing below is primarily focused upon institutions. But I cannot—you cannot—ignore the potential of one-to-one creation, publication, exhibition, and collection. In the next edition of this guide, I predict the single creators seeking patrons online will be long, rich, and critical to the understanding of our transforming digital culture. The book, the work of art, the film, the video, and the URL are at last within a click of your touch, if not your ownership.

GENERAL ART E-COMMERCE

AllArtPortal.com
http://www.allartportal.com/

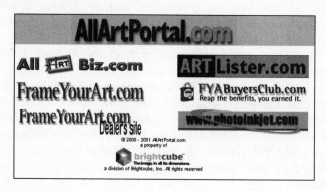

ArtAffairs.com
http://www.artaffairs.com/

ART SUPPLIES

ArtCity
http://www.artcity.com/

Dick Blick Art Materials
http://www.dickblick.com/

Pearl
http://www.pearlpaint.com/

Utrecht
http://www.utrecht.com/

BOOKSELLERS

Amazon.com
http://www.amazon.com

Art Book Services
http://www.artbookservices.com/

ARTEXT
http://www.artextbooks.com/

Barnes & Noble.com
http://www.bn.com

Powell's Books
http://www.powellsbooks.com/

Shipley
http://www.artbook.co.uk/

Strand Book Store
http://www.strandbooks.com

Worldwide Books
http://www.worldwide.com/

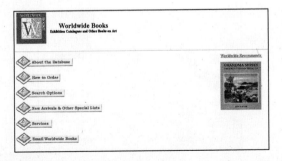

AUCTIONS AND AUCTION INDEXES

Amazon.com
http://www.amazon.com

Art Sales Index Ltd.
http://www.art-sales-index.com/

Artprice
http://www.artprice.com

Biddington's
http://www.biddingtons.com/

Bonhams
http://www.bonhams.com/

Butterfields
http://www.butterfields.com

Christie's
http://www.christies.com

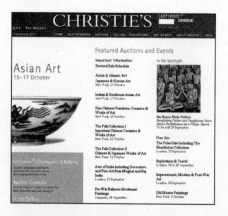

eAuctionRoom
http://www.eauctionroom.com/

eBay
http://www.ebay.com

Gordon's Art Reference
http://www.gordonart.com

Internet Art Auctions
http://www.internetartauctions.com/

Sloan's
http://www.sloansauction.com/

Sothebys
http://www.sothebys.com/

FINE ART
(excluding auctions)

artline
http://www.artline.com

Artnet.com
http://www.artnet.com

DArt: The Internet art database
http://dart.fine-art.com/

eArt Group
http://eartgroup.com

Guild.com
http://www.guild.com/

NextMonet.com
http://www.nextmonet.com/

IMAGE LICENSING

Art Resource
http://www.artres.com

(See entry in ART RESOURCES.)

Scala Picture Library
http://scala.firenze.it/in.dir/

(See entry in ART RESOURCES.)

POSTERS AND PRINTS

AllPosters.com
http://www.allposters.com/

Barewalls
http://www.barewalls.com

Global Gallery
http://www.globalgallery.net

BEYOND CATEGORY

Though this codicil to our book is brief, it points toward an uncategorizable phenomenon more meaningful than any of the crisp, solid listings that have been presented to you so far. No one, least of all this writer and his colleagues, can prescribe what lies ahead in terms of creative expression on the Web. Certainly it won't fit neatly into pigeonholes like "art," "criticism," "media," "journalism," "history," etc. Already you can find hundreds, if not thousands, of examples of what I am trying desperately to define here. Type the words "live camera" into any browser, for example. Immediately you'll find yourself faced with a myriad of lonely, unmanned cameras switched on everywhere. They offer vivid documentation and instantaneous self-revelation such as the world has never seen before. The devil in me wants to link up this unrestrained access to studios, living rooms, street corners, art galleries, hilltops, and offices—Lorene's, say, in Los Angeles, which is often vacant (she has a terrific work schedule)—with the punishment visited by God upon Adam and Eve for knowing each other too well. The saint in me wants to counter and say that knowledge, or what has been called "emotional intelligence," is divinely inspired. The more we see what the other sees and knows—from his window in Kabul, Afghanistan, say, or from the top of a battered, shaken office building in downtown Manhattan, or from a student's overcrowded painting studio at Osaka University of Arts in Japan—the more we will know about joy, suffering, and creativity wherever it occurs. As I finish this book I am shown a portable Web camera for sixty-nine dollars that I can perch on my tiny laptop and take with me wherever I go (plane, train, or

bus) enabling me—and you—to speak, write, and display whatever occurs to us at any moment, whether moved by horror or beauty. It is not impossible to imagine an astronaut or cosmonaut showing us what he/she thinks or hears on the approach to the most distant point in time and space for it is already available, as still image, via the Hubbell Telescope website. Nor is it impossible to imagine another Shakespeare, moved by the beauty of the face I just saw, beginning to say, or type "Shall I compare thee" This is what we mean when we post this last warning: the ultimate art on the Web will surely leave what we think of as art—and its categories—far behind.

The American Dime Museum
http://www.dimemuseum.com/

If art on the Net has a left wing it also lurches occasionally to the right. The American Dime Museum, physically sited in Baltimore, lives on a thoroughly populist fringe. You can see paintings, objects, posters, texts, and more that range across the field of historic performance devoted to "variety and novelty entertainment." What does this mean? Burlesque, vaudeville, Fiji mermaids, shrunken heads, giantess mummies, and a riot of banner greats. How can you resist the American Dime Museum? Confess: you can't.

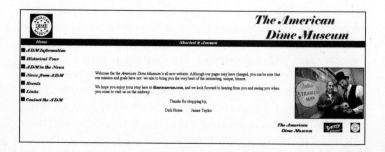

The American Museum of Beat Art
http://beatmuseum.org

The Body of Michael Daines
http://members.home.net/mdaines/ebay.html

In April 2000, Canadian high school student Michael Daines auctioned his physical self on eBay: "The body of a 16-year old male. Overall good condition with minor imperfections." Conceptual art redux, yes, but it also daggered one of the Web's prime free-for-all auction sites. It also, alas, led the eBay CEOs to ban auctions of this kind. Out beyond eBay, however . . . watch out!

disinformation
http://www.disinfo.com/

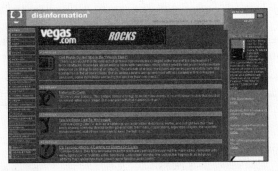

GRRRR.NET
http://www.grrrr.net

Simple and narrative, GRRRR.NET is a glimpse into a private world. The site is filled with personal stories told in comic book format. *A. G.*

Hubble Space Telescope Public Pictures (from the Space Telescope Science Institute)
http://oposite.stsci.edu/pubinfo/pictures.html

Interesting Ideas
http://www.interestingideas.com/

Museum of Dirt
http://www.planet.com/dirtweb/mainmenu.html

The content here is dirty but far from X-rated. Oddly enough, this attractive site explores the esthetic beauty and inherent sentimentality in a bottle of dirt. No wonder Glenn Johanson's "curated" virtual museum has received praise from Yahoo! and the *New York Times*. You can almost smell Mount Everest or Elvis's backyard. Just be glad the Internet is between you and the vial labeled "Love Canal." Be sure to peruse Rejected Dirt for letters from the personal assistants of Jimmy Stewart and George Lucas denying invitations to participate in a "worldwide soil sampling." You will dig it. *v.c.*

Sublabh International Museum of Toilets
http://www.sulabhtoiletmuseum.org/

Roadside America
http://www.roadsideamerica.com/

"Your online guide to offbeat tourist attractions."

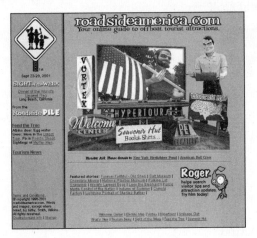

RTMark
http://rtmark.com

Ubuweb
http://www.ubu.com

A quarterly "literary" review that redefines itself online. You see, read, and hear nontraditional poetry in three main categories: visual, sound, and found. The "heard" stuff is sizzling: go to the MP3 Sound Poetry Archive and listen to the late William Burroughs chant his "Break Through in Grey Room." The menu, which can be scrolled from the left-hand side of any page, offers you an Artist Index, Recent Additions, Historical,

Contemporary, Sound, MP3 Archive, and Papers about the multimedia form of poetry—everything from animations to cut-ups, as well as submission guidelines, resources, and the editor's e-mail address). On the right-hand side of the page you can browse through all kinds of poems, including, best of all, Found and Insane, which includes graffiti recorded by some genius (the Editor?) on the street. You need Flash for the animated poems and RealPlayer for audio samples.

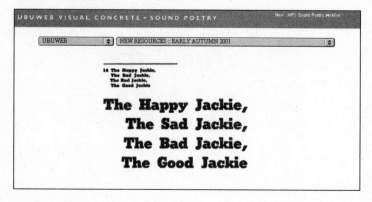

Urban Desires
http://www.urbandesires.com

A big, throaty e-zine with infinite media extensions. Art is the core of this site, both in design and attitude, but it covers everything: politics, society, sex, theater, film, and video. Too rich and dense for its own good, Urban Desires is difficult to navigate: in the middle of the homepage you're offered an animated bird that can fly into sections labeled Asphalt, Crimson, and Ether which take you, in turn, to random articles about style, sex and health, and art. But where the moving image and reviews are concerned, this site is superb. With QuickTime you can view videos, films, and interviews with artists.

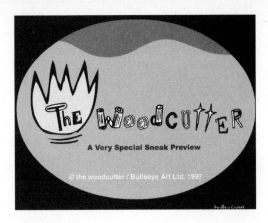

The Woodcutter
http://thewoodcutter.com/

The Yes Men
http://www.the yesmen.org

What's wrong with this picture? A performance artist masquerades as a doctor and speaks to a group of distinguished international lawyers on the ideology of the World Trade Organization. See the bogus PowerPoint presentation, view the streaming video coverage, and read email correspondence. A controversial experiment in art and politics. *v. c.*

ACKNOWLEDGMENTS

With fervent thanks to my valiant, inspired editor, Valerie Cope; to my colleagues, especially those listed below, who contributed to the creation of this book; to my agent, Anthony Furman; to my publisher, Byron Preiss; and to the *New York Times*, which first commissioned the research on which an article and this book are based.

CONTRIBUTORS

Alex Galloway is director of content and technology at Rhizome.org, a leading online platform for new media art. Alex is currently working on a Web-based artwork called *Carnivore* (after the FBI software of the same name).

Vladimir Salnikov lives and works in Moscow. He is an artist, writer, professor, and art critic for Moscow's *Chudozhestveny Zhurnal* art magazine.

Cristine Wang is an independent new media curator, critic, and journalist. She was curator of the "Re: Duchamp Traveling Exhibition" at the49th Venice Biennial, Italy, 2001. She is contributing editor for *NY ARTS* magazine and art editor of *A Gathering of the Tribes Magazine*.

Edward S. Weiss is a consultant in webpage design who has collaborated with Douglas Davis and others, including author Daniel Pinkwater. He is also a freelance writer and is studying at the University of Toronto.

Nina Zaretskaya, Ph.D. was born in Moscow and currently lives and works in Moscow and New York. She is a TV journalist, producer, videomaker, curator of media arts, and founder and director of the Art Media Center TV Gallery.

ABOUT THE AUTHOR

Douglas Davis is a unique American artist, writer, performer, critic, teacher, and digital media consultant. He has been widely exhibited and published, often constructing seminal works of theory and championing the work of unfashionable artists later seen as central to contemporary culture. His first book, *Art and the Future: A History/Prophecy of the Collaboration between Science, Technology, and Art* (1973), now out of print, is a widely translated classic. Arthur Danto said of *The Museum Transformed* (1991) that it "sets the standard" for all subsequent works in this field. Donald Kuspit has called him "one of the more magnificent minds engaging modern art and media."

His groundbreaking work as an artist employs wit, content, and sexuality in equivalent degrees. Among the first artists to use both video and the Web, he pioneered the use of "live" video transmission on CATV and satellite. His early prints brought the spontaneity and immediacy of video to flat paper while his later installations and mural-scale digital photographs bring the distant "virtual" Web down into the viewer's space. *The World's First Collaborative Sentence,* commissioned in 1994 by the Lehman College Art Gallery, was purchased early in 1995 by Mr. and Mrs. Eugene M. Schwartz, then donated to the Whitney Museum of American Art, which now maintains its ever-evolving content. "The true significance of Davis' art," says David Ross, "is the transformation of immediacy into discernible form."

He has taught at Bard College, Columbia University, UCLA and ArtCenter in California, as well as throughout Europe and Asia. In 1995 he was Fulbright lecturer at the Russian State University in Moscow.

URLs and texts by Douglas Davis can be accessed and downloaded at *http://douglasdavis.net.*

The Downloadable Modern Artists

William Morris, George Seurat, Gustav Klimt, Edvard Munch were all great masters of the modern art movement, and they and others are all explored in this accessible and compact primer.

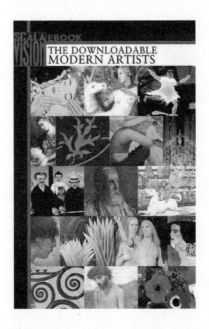

On sale now at *http://www.ipicturebooks.com/scala.html* and *http://www.amazon.com.*

Learn about the modern art movement in this basic and reliable guide, the equivalent of eighty to one hundred "print" pages. A selection of nearly thirty paintings in full color is included, drawn from the matchless archives of La Scala.

The Downloadable Neoclassical Artists

In this ebook, the neoclassical period comes to life through some of its most well-known masterpieces. David's The Oath of the Horatii, Goya's the Execution of May 3, 1808, and Ingre's Apotheosis of Homer are just a few the paintings described and pictured in this book.

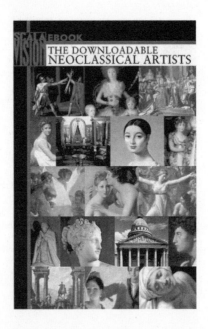

On sale now at *http://www.ipicturebooks.com/scala.html* and *http://www.amazon.com*.

Learn about the neoclassical period in this basic and reliable guide, the equivalent of of eighty to one hundred "print" pages. A selection of nearly thirty paintings in full color is included, drawn from the matchless archives of La Scala.

The Downloadable Musee d'Orsay

The Musée d'Orsay holds some the most extraordinary master-pieces by Ingres, Klimt, Whistler, Cézanne, Degas, van Gogh, and Renoir. This art ebook gives a brief history of the French museum and highlights some of its impressive collection.

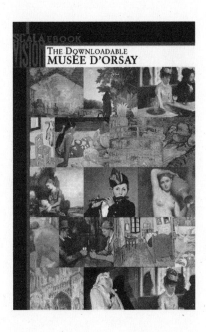

On sale now at *http://www.ipicturebooks.com/scala.html* and *http://www.amazon.com*.

Learn about the Musée d'Orsay in this basic and reliable guide, the equivalent of eighty to one hundred "print" pages. A selection of nearly thirty paintings in full color is included, drawn from the matchless archives of La Scala.

The Downloadable Renaissance

Take a brief art history lesson on the incredible artistic period called the Renaissance with this ebook. This book gives profiles on the masters, including Botticelli, Raphael, da Vinci, Dürer, and van Eyck, and features a sampling of their works.

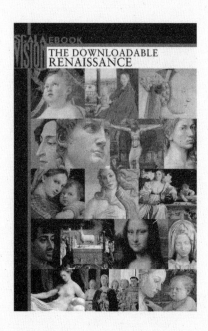

On sale now at *http://www.ipicturebooks.com/scala.html* and *http://www.amazon.com*.

Learn about the Renaissance in this basic and reliable guide, the equivalent of eighty to one hundred "print" pages. A selection of nearly thirty paintings in full color is included, drawn from the matchless archives of La Scala.

The Downloadable Romantic Artists

Corot, Rousseau, Delacroix . . . all the Romantic masters are covered in this accessible ebook, along with a brief introduction on the artistic movement.

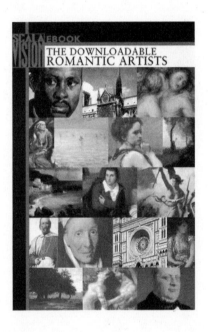

On sale now at *http://www.ipicturebooks.com/scala.html* and *http://www.amazon.com.*

Learn about the Romantic movement in this basic and reliable guide, the equivalent of eighty to one hundred "print" pages. A selection of nearly thirty paintings in full color is included, drawn from the matchless archives of La Scala.

The Downloadable Uffizi

Come in and enjoy the world famous Uffizi Gallery and its masterpieces. After a brief history of the building and Italian painting, this ebook highlights the gallery's treasures, including paintings by Giotto, Bellini, and Botticelli.

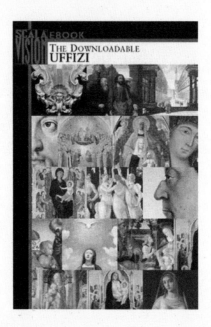

On sale now at *http://www.ipicturebooks.com/scala.html* and *http://www.amazon.com.*

Learn about the Uffizi gallery in this basic and reliable guide, the equivalent of eighty to one hundred "print" pages. A selection of nearly thirty paintings in full color is included, drawn from the matchless archives of La Scala.